荒木　真

MINOL ARAKI

Claudia Brown

Richard Barnhart

Steven D. Owyoung

MINOL ARAKI

National Museum of History in Taipei
December 24, 1998 through January 17, 1999

Phoenix Art Museum, Phoenix
May 15 through July 18, 1999

Published by Phoenix Art Museum

Photography:
Kazukuni Sugiyama, pages 6, 12, 15
John Bigelow Taylor, pages 2, 76-77, 110-111, 114, 119, plates 4, 12, 13, 15-17, 20, 24-27, 29, 30, 33, 36, 37, 41, 42, 46-48, 52, 54, 60, 62
Lin Tsung-hsin, Taipei, pages 90-91, 102-103, plates 2, 18, 19, 21-23, 28, 31, 32, 34, 35, 38-40, 43-45, 49, 55-59, 61

Cover: CHERRY TREES LIKE CLOUDS, 1990, ink and color on paper, 180 x 180 cm in 2 panels (detail)
Endpapers: MOUNTAIN FOREST, 1982, ink on paper, 47.9 x 188.5 cm (detail)
Page 2: LOTUS POND, 1986, ink and color on paper, 90 x 360 cm in 2 panels (detail)
Pages 30-31: DISTANT ROAD, 1978, ink on paper, 92 x 187 cm (detail)
Pages 76-77: LOTUS POND, 1992, ink and color on paper, 180 x 360 cm in 4 panels (detail)
Pages 90-91: BIRD, 1978, ink and color on paper, 69.7 x 138.6 cm (detail)
Pages 102-103: RECLINING NUDE, 1980, ink and color on paper, 69.5 x 140.2 cm (detail)
Pages 110-111: SNOW MONKEYS AT PLAY IN AUTUMN AND WINTER, 1992, ink and color on paper, 90 x 2160 cm in 12 panels (detail)

Design and Production: Tomoko Makiura and Paul Pollard, NYC

Library of Congress Cataloging-in-Publication Data
Brown, Claudia.
Minol Araki / Claudia Brown, Richard Barnhart, Steven D. Owyoung. -- 1st ed.
p. cm.
Catalog of an exhibition held at the National Museum of History in Taipei, Taiwan, Dec. 24, 1998-Jan. 17, 1999 and
the Phoenix Art Museum, Phoenix, Ariz., May 15 - July 18, 1999.
ISBN 0-91-040736-3 (hardcover: alk. paper)
I. Araki, Minol, 1928- --Themes, motives -- Exhibitions.
I. Araki, Minol, 1928 - . II. Barnhart, Richard M., 1934- . III. Owyoung, Steven D.
IV. Kuo Li Li shih po wu kuan (China). V. Phoenix Art Museum. VI. Title.
ND2073.A62 A4 1999
709'.2 -- dc21
98-50148
CIP

First Edition

Printed and bound in Hong Kong

CONTENTS

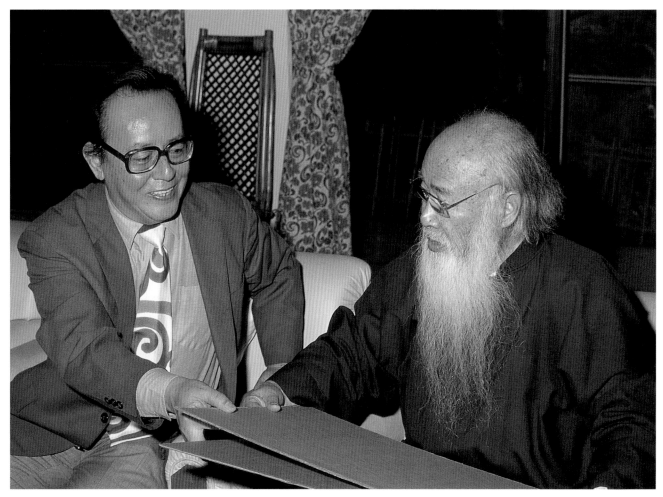

Minol Araki and Chang Dai-chien, Taipei, September 1981

CAPTURING THE SPIRIT

In celebration of the 100th anniversary
of the birth of Chang Dai-chien
-Master and Friend-

The true artist must try to bring out, between likeness and unlikeness, the extramundane charm of nature. That is what the ancients mean by "**capturing the spirit** at the expense of appearance." The artist sees what is truly beautiful and paints it, while rejecting what is not beautiful. True beauty does not dwell solely in the outward form of things but must be appreciated through its spiritual vitality. This may be coupled with the famous dictum of the eminent T'ang Dynasty poet-painter, Wang Wei: "In a picture there should be poetry, in a poem there should be a picture." For painting is poetry unsung, and poetry is painting set to music. To attain such a transcendent state, it is imperative to conceive the picture before manipulating the brush, so that as soon as an inspiration sparkles in the painter's psyche, it may take shape on the paper by means of brush and ink. And so it is said: "The form is born ahead of the brushwork the spirit dwells in the completed brushwork."

Chang Dai-chien, *On the Art of Painting*

ACKNOWLEDGMENTS

This volume is published on the occasion of the first international travelling exhibition of the work of Minol Araki. Both projects result from the remarkable efforts of David Frank and Kazukuni Sugiyama. Their vision and their unflagging enthusiasm have inspired the many contributions of individuals in the United States, in Taiwan and in Hong Kong.

In the United States, interest in documenting Minol Araki's work first arose in 1995. Former Ambassador to Japan Mike Mansfield took an early interest in Araki and his work. Gil Winter was indispensable for early introductions to the Asian art world in the United States.

Rand Castile, Director Emeritus of the Asian Art Museum of San Francisco, Sondra Castile of the Metropolitan Museum of Art, New York, and Gunhilde Avitabile, former Director of the Japan Society Gallery, New York, lent their support early on and have continued to offer advice and assistance to the project. Alexandra Munroe, Director of the Japan Society Gallery, also gave her encouragement.

Scholars in the field of Chinese painting came to support the project as well. Howard and Mary Ann Rogers of Kaikodo gave generously of their time and advice and introduced the talented team who worked on this catalogue. Steven D. Owyoung, Curator of Asian Arts at the Saint Louis Museum of Art, and Richard Barnhart, Professor of Art History at Yale University, contributed the illuminating essays found herein. Robin Burlingham of the Herbert F. Johnson Museum of Art, and An-yi Pan, Assistant Professor of Art History at Cornell University, provided additional expertise in preparation of the catalogue.

New York designers Tomoko Makiura and Paul Pollard created the exceptionally beautiful book design. Their efforts together with the excellent editorial work of Sheila Schwartz have produced a volume of singular beauty. John Bigelow Taylor, also of New York, and his associate Dianne Dubler produced the excellent photographs of the New York group of Araki's paintings.

Additional thanks are due to poet Carl Morton, New York, and to Richard Stevenson of Mesa Arizona who read the manuscript and offered many valuable suggestions. Architect Tod Williams of Tod Williams/Billie Hsien, New York, made many helpful comments. Anna Kurita Foard provided additional assistance with translations. The organizers of the exhibition gratefully acknowledge Diane Frank for the generous loan of her painting, *Landscape* (plate 6).

In Taiwan, Huang Kuang-nan, Director of the National Museum of History in Taipei, has provided leadership and encouragement for the exhibition of Minol Araki's paintings held in commemoration of the 100th anniversary of Chang Dai-chien's birth. Su Chi-ming and Chen Yu-chen of the curatorial staff of the National Museum of History have contributed their efforts toward the exhibition.

Also in Taipei, art historian Fu Shen of the Academia Sinica, formerly Curator of Chinese Art at the Arthur M. Sackler Gallery, Smithsonian Institution, Washington D.C., and the leading scholar on the art of Chang Dai-chien, offered his support and advice.

Li Yu-lin of the Taipei Fine Arts Museum gave her encouragement. Chang Sung-hsien in Taipei created flawless mountings for Araki's paintings and provided invaluable assistance in facilitating arrangements with the National Museum of History. Lin Chen-yung, based on his long friendship with Araki, provided translations of Araki's comments from Japanese into Chinese. Photographer Lin Tsung-hsin produced the excellent photographs of the Taiwan group of Araki's paintings.

In Hong Kong, editor Elizabeth Knight has provided the essential expertise which has resulted in this beautiful volume. Additional assistance in production and proof-reading has been provided by Ou Da-wei, who also engraved many of Araki's seals.

As organizing curator of the exhibition, I wish to thank James K. Ballinger, Director of the Phoenix Art Museum, and Michael Komanecky, Chief Curator, for their support of this project, and to acknowledge David Restad, Exhibition Designer, Gene Koeneman, Chief Preparator, Heather Northway, Registrar, who together with their staff members at the Phoenix Art Museum have contributed to the success of this exhibition.

Claudia Brown
Arizona State University and Phoenix Art Museum
Organizing Curator and Editor of the Catalogue

前　言

日本畫家荒木實於民國十七年出生於大連，在中國成長，久沐中華文化，故醉心於傳統書畫，而立志以藝術為終生事業。

荒木實先生師學中國歷代大師相傳之偉大作品，並曾習藝於張大千，鑽研水墨畫理，追求意境。在其所寫水墨畫中，荒木實以傳統的中國與日本技法融入現代生活主題，其獨特的繪畫風格與方式，頗受藝林推許。他無論身在何處，隨時都以水墨抒發最新創意及感受，描繪出個人對大自然及人類的熱愛，其畫境的超逸氣質，令人印象至為深刻。

此次畫展包括了荷花、花鳥、人物與山水等多元主題，傳述畫家個人近年來旅居美國、日本與台灣的生活紀實與感念。靜觀其畫，宛如大千筆墨的氛圍可泊泊感受，中國藝術與文學的融合氣氛也如詩般地飄然而出。

黃光男 謹誌

國立歷史博物館館
黃光男博士 謹上
一九九八年十月

P R E F A C E

The Japanese painter Minol Araki was born in 1928 in the city of Dalian, Liaoning province, in northeastern China. He grew up there and was influenced by Chinese culture. Steeped in traditional Chinese painting and calligraphy, he was inspired to choose art as his career. Mr. Araki studied the great works of masters of successive dynasties, and learned ink painting under Chang Dai-chien. In his work, Araki combines traditional Chinese and Japanese techniques in his paintings of modern life. His unique painting style and technique have been highly praised in the art world. Wherever he goes, he uses ink painting to express his innovation and feeling and depict his passion for nature and humankind. The untrammeled quality of his works is impressive.

This exhibition includes subjects such as lotus, flower-and-bird, figures, and landscapes, representing the artist's works of recent years done in the United States, Japan, and Taiwan. When contemplating his works, one feels the atmosphere of Chang Dai-chien's brush idiom and the synthesis of Chinese art and literature in Araki's poetic expression.

Kuang-nan Huang, Ph.D.
Director
National Museum of History in Taipei
October, 1998

FRUIT FROM THE WILD TREE: THE PAINTINGS OF MINOL ARAKI

Claudia Brown

Traditional painting, carried out with ink and colors on a paper ground, has continued to flourish in China and Japan in the 20th century, despite the adoption of oil painting and other Western art media. The styles of painting associated in imperial times with China's scholar-officials, often called the literati, had spread to Japan and continued to flourish there as *bunjinga* (Japanese for the Chinese term *wenren hua*, or literati painting). Painters following this tradition subscribed to an art theory in which the practice of painting was independent of commercial gain and professional ambition; rather, it provided an avenue for self-expression. In the late 20th century, however, that belief has declined and it is exceedingly rare to find a painter — in China or in Japan — who would still maintain the separation of painting from professional success or, at least, from making a living. While many still emphasize the self-expression possible within painting, few can be considered independent from the art market. This rare quality, however, characterizes the remarkable life and work of Minol Araki, a Chinese-born Japanese industrial designer who, successful in his design career, has pursued painting for its own sake.

Biography

Minol Araki[1] was born in 1928 in the thriving industrial city and port called Dairen (now Lüda, also called Dalian) in Liaoning Province, at the tip of the Liaodong Peninsula, once part of Manchuria. Together with nearby Port Arthur (now Lüshun), the area had been captured by the Japanese in the Sino-Japanese War of 1894-95, but was soon returned to China, then under the Qing dynasty. By 1898, it had been leased by the Russians, who improved the port and maintained it as the ice-free port for their Pacific fleet. They built up a neighboring village, which they called Dalny, in order to have an additional commercial port and a rail link to Harbin. Dalny soon was ceded to the Japanese at the conclusion of the Russo-Japanese War of 1904. Renamed Dairen, the modern city was completed and the port improved as planned by the Russians. Soon Dairen (sometimes spelled Dahren) was a major industrial city with railroad industries, machine building, shipbuilding, a cement works, and a chemical industry. Immediately after World War II, the Soviet Union occupied the city. The Japanese inhabitants were evacuated to Japan. The Yalta conference proposed joint use of the Port Arthur military base by the Soviet Union and China for thirty years, but the Soviets withdrew from the port in 1955. Industrial development at Dairen, now Lüda, had slowed, but in 1957 the Chinese government proclaimed it to be flourishing once again.

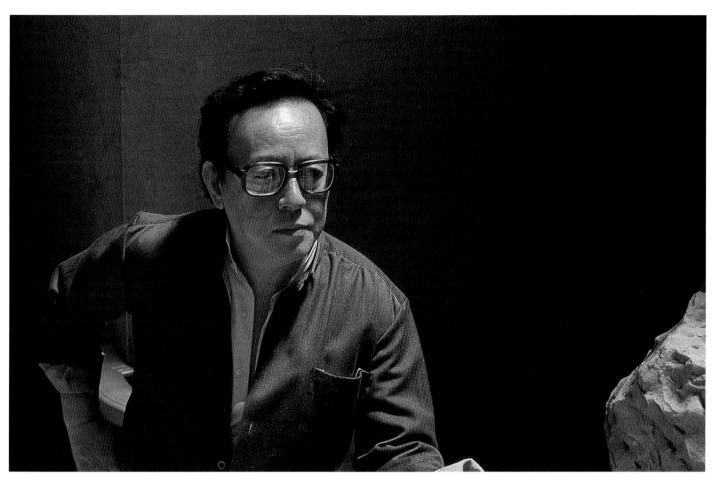

This background of multiple cultures in Dairen had an early influence on Araki. Growing up in an artistic family, he started to paint at a young age. At seven, he began studying painting under the guidance of an old Chinese painter who was a friend of his parents. Later he wanted to go to art school, but his parents urged a more practical training. As a compromise, he studied architecture at Nanman Kosen in Dairen (1945). After the end of World War II, he had to interrupt his study and return to Japan with his family. Araki recently recalled the event:

> Around March 1945, following the expected, but very sudden order "return to Japan," my mother, two sisters and I rushed to Dahren port. The ship was a cargo ship and not so big. Each of us carried one Boston bag and one sack. In my bag, which was my late father's and made of leather, I put materials for sketching and my favorite big sausages. As a boy of 17, I had no dark memories and looked forward, as in a dream, to the unknown country of Japan. My mother and my sisters, on the other hand, could not hide their tears.

> Finally, we arrived in Maizuru. At first sight Japan seemed as a miniature garden compared to the vastness of China and I remember feeling uneasy.[2]

By 1947 he had resumed his studies at the Kuwazawa Design School in Tokyo. Influenced by the book *Never Leave Well Enough Alone* by Raymond Loewy (published in 1951),[3] he decided to pursue a career in industrial design. The study of design, he felt, was closer to the "real art of his dreams."

Araki's professional career, as a designer of housewares and electronics for Nanbu Industries, Tandy Corporation/Radio Shack, Shenpix, and other corporations, took him frequently to Taiwan and Hong Kong as well as to the United States. Throughout these years he continued to paint, and by the 1970s his painting efforts intensified. In 1973, he first met the painter Chang Dai-chien (1899-1983) in Taipei. The introduction was made through the painter Yao Mengku,[4] who had watched Araki sketching lotuses at the pond in front of the National Museum of History in Taipei.

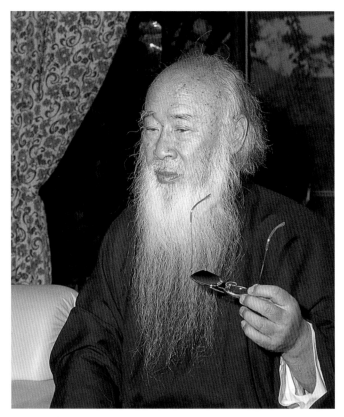

Chang Dai-chien, Taipei, September 1981

In the late 1970s, Araki painted one of his most important landscapes, *Distant Road* (plate 1), and soon after he completed *Distant Road II* (plate 3). In these he set out his personal style of wet-on-wet washes of inks and colors within a diagonally composed arrangement of peaks and valleys. The use of brush and ink may owe inspiration to his mentor, Chang Dai-chien, but the compositions seem quite independent of that great master, relying as they do on the meandering but strongly delineated motif of the road. The straightforwardness of this approach may stem from the demands of the format, already a precursor of the multiple panel series he would create later in the 1980s. At the same time Araki was formulating these landscapes, he also was painting faces and figures (plates 44-50) in abbreviated, expressive brushwork. During this burst of creative activity, he also painted several of the most traditionally Chinese works in his oeuvre, including the *Thinking Bird* (plate 36) and the small format paintings of fish, bamboo, and cabbage (plates 58, 59, 60). This was apparently a period of broad experimentation for him, since he also produced some of the most "Western" of his works at this time, including abstractions (plates 55, 56, 57), still-life compositions (plates 39, 41),

and *Pier* (plate 53), a landscape painted in Europe, of "European" inspiration.

Throughout the 1980s, Araki returned again and again to the landscape (*shanshui*, literally "mountain and water" pictures). He expanded his multiple, modular panel format to stretch 70 feet in twenty-four vertical panels (*Panoramic View of Dreamy Landscape*, 1980, plate 9) or in twelve horizontal panels (*Hekiba Village*, 1985, plate 14). By the late 1980s, he had begun to work in a manner inspired by Nihonga, the traditional Japanese painting of this century. His two-panel *Silent Night* (1989, plate 13) and the subsequent *Mount Fuji* (1992, plate 12), together with *Cherry Trees Like Clouds* (plate 62), reflect his interest in the broad, flat areas of color typical of Nihonga. This development culminates in the artist's monumental *Snow Monkeys at Play in Autumn and Winter* (70 feet long in its full span, 1992, plate 54). Araki's series of lotus paintings (1986-1997, plates 25-35) are contemporary with these works. The lotus paintings, one of Araki's most important series, reveal the convergence of profound emotions, traditional associative meanings, and the acute observation of the growth of these remarkable plants. Landscape, however, with all its primal associations, has always held Araki's interest as we see in his latest work in the *Landscape with Ancient Trees* (1997, plate 21).

One of the most distinctive accomplishments in Araki's oeuvre is his redefinition of the format of the traditional Japanese folding screen, the *byobu*.[5] Inspired perhaps by this unique format, which evolved as an adjunct to Japanese architecture, he has created a mural format of even larger scale. Each panel is the size of a traditional *tatami* floor mat, itself a module in traditional Japanese architecture. (Room size in a traditional building is measured by the number of mats needed to cover the floor.) Araki preserves the aesthetic of multiple compositions, each of which can stand on its own or be part of the greater whole. However he increases the scale and adds the Western convenience of mounted pictures that can hang on the wall. This in turn enhances the pictorial and illusionistic nature of the paintings in an unprecedented way.

Art and Design

Is there a relationship between Araki's professional work and his painting? It might be argued that the first aesthetic influence of his career was that of Raymond Loewy (1893-1986), the French-born American designer whose product designs, from the 1930s on, established industrial design as a profession. Best known for his Lucky Strike cigarette package, his Studebaker autos,

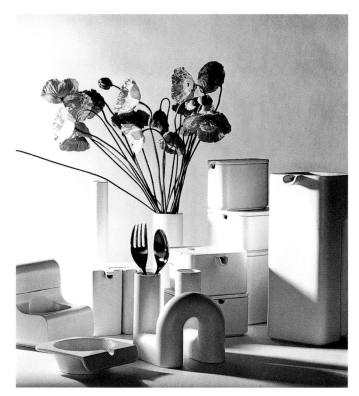

Three-way Nanbu lamp. Designed by Minol Araki for Nanbu Industries, early 1960s.

Two perpetual calendars designed by Minol Araki, c. 1969.

Modular housewares designed by Minol Araki, c. 1969, including cigarette holder, ashtray, oil and vinegar containers, napkin and silverware holder, flower vase, sugar and creamer, canisters, and water pitcher.

and his Coca-Cola bottle, Loewy is noted for the "streamlined" vision of beauty he brought to the functional forms of automobiles, locomotives, buses, and airplanes as well as ordinary consumer products such as toothbrushes, ballpoint pens, radios, and appliances for the home and office. He referred to himself and his associates as "apostles of simplicity."[6] This point of view may have resonated with Araki's own training.

Throughout his life, Araki did not collect old paintings, as so many artists have done, but instead collected antique implements of painting, including ink, ink stones, paper, and brushes. Perhaps it is a designer's inclination to treasure such tools. Beyond that, did Araki's professional work affect his painting directly? Chang Dai-chien studied textile dyeing, and scholars have pointed to a possible connection between that experience and his painting.[7] In Araki's case, might we look to the ingenious modular format of his large series paintings as an element inspired by his design work? Finding beauty in the simplest solutions to problems is a designer's dream, and creating new interpretations of accepted forms is part of the training. Araki's transformation of the folding screen into a new format of seried panels may stem from this aspect of his development.

The Literati Spirit

As scholarly studies and museum exhibitions have made clear, the styles and techniques of traditional Chinese and Japanese painting have continued to thrive throughout this century.[8] However, the practice of painting has been fundamentally altered by social changes. While painting was once considered by many artists — primarily China's scholar-officials — an expressive outlet that could remain separate from the commercial world, it has now become a professional pursuit.

The roots of this modern professional approach in painting are often traced to 18th-century Yangzhou, where the artist and retired official Zheng Xie (1693-1765) emphasized that his paintings were available only through cash transactions.[9] In the commercial economy of Yangzhou and later in Shanghai, the new urban patrons for art, as well as the increasing importance of such specialized skills as portraiture and print design,[10] furthered the commercialization of painting.

Nearly all of the well-known Chinese traditionalist painters of our century — including Chang Dai-chien — have been professional artists. Contact with the West has brought emphasis on

commercial sales as an indicator of the merit of an artist. The rise of professional art and design schools played a major role in this evolution as well. The modernization of government and education in China, Taiwan, and Hong Kong has meant that virtually all traditional painters have become professionally involved in the arts — if not as artists who live by selling their paintings, then as teachers, art historians, or art dealers. Painting as an avocation exists among art historians, professors in art colleges and art dealers, but this is quite different from the separation of profession and avocation among the literati of the past.

While this rise in both professionalism and commercialism was in many ways a good thing, it also meant the loss of that unique independence that a true amateur status conveyed. The literati spirit remained, but its practice declined. In China, the literati tradition was codified into an acceptable art school curriculum,[11] as Guohua or national painting. In Taiwan and Hong Kong, too, it came to be a medium for painting (opposed to the oil painting tradition or the contemporary trends of art stemming from the postwar expressions of American and European artists). Literati painting has thus been transformed into a style and no longer offers independence from commercial concerns.

Wenren hua, China's tradition of painting by literary men, had spread to Japan in the 17th century and flourished there as *bunjinga.* The movement's success in China had been tied to the government practice of recruiting officials with a literary background through a civil service exam. Japan had no parallel government practice, and artists there who embraced the *wenren hua/bunjinga* tradition could not follow the standard model of finding a vocation in government service and an avocation in painting and poetry. Nevertheless, interest in this manner of painting — both a style and a lifestyle — survived in the 20th century, notably in the life and work of artist Tomioka Tessai (1837-1924). Tessai was a *bunjin* painter whose Confucian beliefs helped sustain him during Japan's period of rapid modernization and Westernization. Following the spirit of these literati, both Chinese and Japanese, Araki has maintained a strong distinction between his professional work as an industrial designer and his entirely non-commercial pursuit of art in the avocation of painting.

Internationalism

The modern world is divided by distinct national borders. Yet personal ties and cultural experience often defy such categorization, as with Araki, who refers to the "two homelands in my heart — one in the Orient, China and Japan, and one in the West, America. Even the Eastern "homeland" cannot be sharply delineated. The invigorating interaction of Japanese and Chinese cultures during the 20th century should not be obscured by emphasis on political events. It has long been recognized that Gao Jianfu (1879-1951) and others of the Lingnan school,[12] one of the first of China's "modern" movements in art, received schooling in Japan and carried home with them ideals developed from Japanese modern institutions and thought. Beyond that, Chinese artists of diverse backgrounds, including Chen Shizeng (Chen Hengke, 1876-1924), Feng Zikai (1898-1975), and Fu Baoshi (1904-1965), all studied in Japan. Chang Dai-chien, too, spent many years in Japan.[13] Araki began painting on what is now Chinese soil and has spent considerable time in Taipei. When he describes his *Snow Monkeys at Play in Autumn and Winter* (plate 54) as monkeys in Nihonga colors within a Chinese landscape, it seems a natural outgrowth of his experience.

Araki's paintings do not rely on the historical allusions that so many 20th-century traditionalists in China and Japan have emphasized. He does not cite models among the great masters. However, when asked about teachers who have been important to him, he responds that there are several artists whom he has profoundly admired. Araki counts among artists who have influenced him Chang Dai-chien[14] and Tomioka Tessai,[15] both mentioned above. He also acknowledges that he has found inspiration in the work of the 17th-century eccentric Bada Shanren (also known as Zhu Da),[16] an artist whose striking monochromatic renditions of birds certainly lie behind Araki's *Thinking Bird* (plate 36) and other works. Also of interest to him have been the 20th-century Chinese artists Fu Baoshi, noted for his richly textured landscapes, Qi Baishi (1863-1957), admired for his simple but dignified compositions of everyday objects,[17] and the work of Yokoyama Taikan (1868-1958), a traditional Japanese painter active in Tokyo who worked in the Nihonga style.[18] Western artists also have inspired Araki. Included among this list is Ben Shahn (1898-1969), the Russian-born New York artist, noted for his sympathetic figure sketches. Araki also acknowledges influence from Picasso (1881-1973), whose classicist, cubist, and surrealist drawings and paintings had worldwide impact.

Minol Araki's paintings are not inscribed,[19] but are signed, sometimes in a manner that suggests the Western practice of signing a work in one of the lower corners. Following Chinese and Japanese tradition, however, Araki generally adds a seal. Like many literati artists of the late 18th and 19th century, Araki designs his own seals. At times he has used his fingerprint

as a seal. Employing handmade papers and a variety of natural ink and pigments, he signs his name with a deep sense of meaning. The character for Minol, he points out, is frequently used in combination with a second character in such combinations as *shinjitsu* (truth), *seijitsu* (sincerity), *jitchoku* (honest, trustworthy), *jitsuz* (real image), and *jittai* (substance, true nature).[20] Araki, in translation, means "rough" or "wild tree" and in combination with Minol translates as "fruit on the rough or wild tree," a name which the artist feels has in many ways shaped his personality.

Araki says: "My painting is a celebration of nature, a grateful song to all forms of creation expressed through brush paintingBy drawing from both East and West, I hope to achieve a perspective which is international, a bridge between cultures."

Notes

[1] The name would normally be rendered Minoru Araki, or Araki Minoru in Japanese fashion. However, the artist has long used Minol rather than Minoru.

[2] Personal communication from the artist. This and additional quotations from the artist, both direct and indirect, stem from correspondence with the artist in summer 1998, aided by David Frank and Kazukuni Sugiyama.

[3] Raymond Loewy, *Never Leave Well Enough Alone* (New York: Simon and Schuster, 1951). The book appeared in German, French, and Japanese in 1953, and in Arabic and Dutch in 1957. In 1953, it was a bestseller in Germany. See Angela Schonberger, ed., *Raymond Loewy: Pioneer of American Industrial Design* (Munich: Prestel-Verlag, 1990), English edition, pp. 149 and 247. For further information on Loewy, who was also noted for the design of the 1937 Coldspot refrigerator, the 1947 and 1953 Studebaker autos, and the Greyhound Scenicruiser bus, see Paul Jodard, *Raymond Loewy* (London: Trefoil Publications, 1992).

[4] On Yao Mengku (Mungo K.L. Yao, 1912-c. 1982), a noted art critic who served as a staff member of the National Museum of History, see Shen Fu et al., *Contemporary Calligraphy and Painting from the Republic of China* (Washington D.C.: Consortium for International Cooperation in Higher Education, sponsored by the National Museum of History, Taipei, 1980), part I, no. 22, and part II, no. 22.

[5] The screen format in general had antecedents in China. The historical development of the screen in China, and its broader implications, has been the object of a fascinating study by Wu Hung, *The Double Screen: Medium and Representation in Chinese Painting* (Chicago: The University of Chicago Press, 1996). The screen format was adopted by European and American artists as well; see Michael K. Komanecky and Virginia Fabbri Butera, *The Folding Image: Screens by Western Artists of the Nineteenth and Twentieth Centuries* (New Haven; Yale University Art Gallery, 1984).

[6] Loewy, *Never Leave Well Enough Alone*, p. 95.

[7] Shen C.Y. Fu with Jan Stuart, *Challenging the Past: The Paintings of Chang Dai-chien*, (Washington D.C.: Arthur M. Sackler Gallery, 1991), pp. 88-89.

[8] Nearly thirty years ago, such scholars as Chu-tsing Li and Michael Sullivan brought to the attention of the American public the fact that Chinese painting, despite its venerable past, or perhaps because of it, was an ongoing, living tradition. Today, 20th-century Chinese art is regularly shown as a part of most museum displays of Chinese art. Large exchange exhibitions have also been organized, such as the current "China: 5000 Years" organized by the Guggenheim Museum, New York, and an extraordinary offering of shows in Vancouver in the project called Jiangnan. Whether traditional painting will survive the present currents of Western, particularly American, popular culture flooding into China now is a greater question.

[9] On Zheng Xie and his famous price list, see Ginger Cheng-chi Hsu, "Zheng Xie's Price List: Painting as a Source of Income in Yangzhou," *Phoebus*, 6, no. 2, pp. 261-71.

[10] Qian Huian, for example, began his career as a portraitist and became an influential painter in Shanghai in the late 19th century. The design of prints, too, became an important practical profession for many artists, who also sold their paintings to make a living. A study on printing in Shanghai has been made by Jonathan Hay, "Painters and Publishing in Shanghai, circa 1875-1895," *Phoebus*, 9, (forthcoming 1998).

[11] This development of an art curriculum has been explored by Hong Zaixin in his paper, "Pan Tianshou and Jiangnan Art Tradition," presented at the international symposium "Jiangnan: Modern and Contemporary Art from South of the Yangzi River," held in Vancouver, April 24-25, 1998.

[12] On this school, see Ralph C. Croizier, *Art and Revolution in Modern China: The Lingnan (Cantonese) School of Painting, 1906-1951* (Berkeley: University of California Press, 1988).

[13] Fu and Stuart, *Challenging the Past*, p. 311.

[14] Asked what he learned from Chang Dai-chien, Araki responded with three principles: study all your life — it will be reflected in your work; a good painting presents both action and stillness; and the beauty of a painting comes from inside the artist. Encouraged by Chang Dai-chien, Araki showed his work in several exhibitions, including one-man shows at the City Hall Museum, Hong Kong (1977 and 1981), and the National Museum of History, Taipei (1978 and 1980). He also participated in group exhibitions, including "Shigen-ten," Tokyo Central Museum (1982), and "L'Exposition France-Japan," Paris (1982, awarded Prix Académie des Beaux-Arts Prix Comparaison; 1983, awarded Prix Société Nationale des Beaux-Arts Prix France-Soir). He has not exhibited his paintings since Chang Dai-chien died in 1983. The present exhibition honors the centenary of Chang's birth.

[15] On Tessai, see Patricia J. Graham, "Tomioka Tessai," in Jane Turner, ed., *Dictionary of Art* (New York: Grove Press, 1996) vol. 31, pp. 135-37. Two special exhibitions of Tessai's work, both titled "The Art of Tomioka Tessai," were organized in Kyoto and traveled in the U.S. The first was organized by The Metropolitan Museum of Art, New York, in the late 1950s and circulated by the Smithsonian Institution; the second was circulated by the International Exhibitions Foundation and was shown at the Phoenix Art Museum, January 15 -February 16, 1969.

[16] On Bada Shanren, see Wang Fangyu and Richard M. Barnhart, *Master of the Lotus Garden: The Life and Art of Bada Shanren, 1626-1705* (New Haven, Conn., 1991).

[17] The works of Qi Baishi and Fu Baoshi are widely published. See, for example, Chu-tsing Li, *Trends in Modern Chinese Painting: The C.A. Drenowatz Collection* (Ascona, Switzerland, 1979), pp. 83-91and 123-36.

[18] On Yokoyama Taikan, see Yoshikazu Iwasaki, "Yokoyama, Taikan," in Jane Turner, ed., *Dictionary of Art* (New York: Grove Press, 1996), vol. 33, p. 541. On the social developments which affected *bunjinga* in Meiji and Taisho period Japan, see Ellen P. Conant with Steven D. Owyoung and J. Thomas Rimer, *Nihonga: Transcending the Past: Japanese-Style Painting, 1868-1968* (Saint Louis: Saint Louis Art Museum, 1995), especially pp. 34-35; on pigments and techniques of the Nihonga painters, see pp. 110-11. Included in the Saint Louis exhibition were works by Yokoyama Taikan (nos. 36, 37, 72) and Tomioka Tessai (nos. 65, 66).

[19] Araki has not used calligraphy itself as an element in his paintings, perhaps because he stands a bit closer to Western pictorial tradition than many traditionalists in modern China and Japan. He studied the basic technique of calligraphy in order to perfect his brushwork technique. The important element of painting he says is "the way the stroke can express strength, speed, elegance or emotion."

[20] Personal communication from the artist, with assistance in interpretation by Anna K. Foard.

A DISTANT ROAD: MINOL ARAKI AND THE ROOTS OF STYLE

Richard Barnhart

One of the art historical challenges posed by the art of Minol Araki is to identify and give names to its sources. In her biographical essay on the artist, for example, Claudia Brown cites the following painters as being among those artists acknowledged by Araki as influences on his art: in China, Chang Dai-chien (1899-1983), Bada Shanren (1626-1705), Fu Baoshi (1904-1965), and Qi Baishi (1863-1957); in Japan, Tomioka Tessai (1837-1924) and Yokoyama Taikan (1868-1958); in the West, Ben Shahn (1898-1969), born in Russia, and Picasso (1881-1973), born in Spain. Raymond Loewy (1893-1986), the American designer born in France, was the strongest influence on Araki's industrial design. So, by simple tabulation, we have artists from six of the most different and distinctive artistic cultures in modern history: China, Japan, Russia, France, Spain, and the United States. This somehow seems a very appropriate, if quite unusual, range of influences in our post-colonial, post-modern, international corporate age. Minol Araki's life and art have spanned a wide range of time and place, and have grown from a variety of roots of deep importance to him. An examination of them may help us understand a little of what he has accomplished as an artist.

Splashed-Ink Landscape

It is clear at the outset that Minol Araki's art is not defined by the sum of the influences that shaped his early life and informed his later studies of painting. His images, so wide-ranging in style and technique, often seem arrived at almost by accident. In his dramatic splashed-ink or splashed-color landscapes, for example, accident is sought out and celebrated as ink and ink wash or color washes flow over the paper to become the substance of mountains and rivers, trees and rocks, sky and earth. The history of this manner of landscape painting is very ancient in China, with roots in the Tang dynasty (618-907), and it has always been a style chosen by those who sought liberation from the restraints and limitations of expectation and orthodoxy. In our time, of course, Chang Dai-chien has given splashed ink and/or color a modern definition that may have become nearly impossible to escape, and a bold dramatic appeal that is likely to preserve it as one of the most popular and influential monuments of 20th-century Chinese landscape painting.[1]

This bold, free style of painting is always a challenge to the vision and technical skills of the painter, and Araki has mastered it with

distinction in ways not at all identical to Chang Dai-chien. In the 1970s, as Araki was just beginning to devote himself to painting, an art he had already studied for thirty-five years, his encounter with Chang led him into a deep exploration of Chang's most celebrated style, and this experience richly informed his techniques and his confidence as a painter. To master splashed-ink on a large scale, as Araki did at that time, is to enter a rarefied realm, to move on to a higher level of understanding and performance. Mastery of large-scale splashed ink landscape must be something like achieving enlightenment in Zen Buddhism. Suddenly, with great clarity, all things become possible. The works produced at the end of that period of Araki's life, especially the two memorable versions of *Distant Road* from 1978 and 1979 (plates 1, 3), reveal a vision and personal sensibility that is already quite clearly that of Minol Araki. At the age of fifty he was a painter with a vision of the future, and it stretched out along a distant road that he has traveled for the past twenty years. The boundaries of art and culture that he has crossed now reach around the world.

In Chinese and Japanese, the title translated as *Distant Road* actually means both distant and eternal. The road we see is forever distant. For a man born in Manchuria to a Japanese family, raised in a region with powerful elements of Russian, Chinese, and Japanese cultural traditions, educated later in a postwar Japan under U.S. administration, and eventually a frequent sojourner in the Chinese cultures of Taiwan and Hong Kong and the modern Western cultures of Europe and America, the distant, eternal road is surely an apt and powerful personal symbol. Araki has been an eternal sojourner wherever he has been, always following distant roads, and as an artist he has defined himself by drawing into his own identify the artistic cultures of Japan, China, Russia, the United States, and Europe.

The Enigma of Identity

Analyzed in this fashion, it would be difficult to imagine how Araki negotiates his path through the thicket of artistic traditions within which he has found his place. Yet, of course, there is no such difficulty, judging from the reality of his painting and its overall consistency within certain boundaries. We must therefore think differently about his art. Born in Manchuria, traditionally part of China, but successively controlled by Russia and Japan, this Japanese artist grew up with the combined

heritage of three great Asian cultures, Russia, China, and Japan. The modern arts of Europe were a distant part of this rich complex even in Araki's youth, as artists from all three countries had been studying abroad since the end of World War I. Modernist tendencies of European art were deeply imbedded in the cultures of China and Japan by the time Araki returned to Japan and began his international quest.[2] And nothing could be more modern or international, after all, than the world of industrial design into which he plunged and in which he has spent his entire adult life. These have been the years during which international corporations have conquered the world, the years in which Araki established his career as a designer for a leading international corporation.

So, perhaps, the seemingly diverse elements of Araki's cultural background can be understood as a natural product of the unusual circumstances of his early and middle life. He was born and raised during the imperialist phase of modern history, a Japanese citizen born in the Japanese colonial state of Manchuria, a state that had been taken by Russia from China and then by Japan from Russia — and that is now again a part of China. And he lived through the turbulent, violent end of the colonial era into the post-colonial, post-modern world that followed in the long aftermath of the World War II. But not immediately, of course, because the postwar Japan to which he returned after the war and in which he was educated was occupied and controlled by United States military forces. Thus, another phase of the colonial era became a part of his background. Only by the time Araki began painting with dedicated purpose in the 1970s were we all living in the modern international, post-colonial world. It would be hard to imagine, from an Asian perspective, a more appropriate representative of that history or of its present condition than Araki. His art can be seen, in one sense, as the natural embodiment of the time and the worlds in which he has passed his unusual life.

When V.S. Naipaul titled one of his novels *The Enigma of Arrival*, he suggested the uncertainties that such transnational citizens as himself had in finding cultural and personal identity in the modern world. Born in Trinidad of Indian parents, resident of Great Britain, teacher in Africa, citizen of the world, Naipaul has roamed the earth, constantly seeking to understand his own cultural identity through understanding his relationships to what he has encountered. Araki Minol has had a similarly rich and complicated life, and appears to have found through his art

a means of bridging the distances, of locating a center that defines him (as, probably, Naipaul has done). Araki can never really return to the place of his birth, which no longer exists as he knew it, and yet he carries its legacy within him. He can also never be a typical Japanese citizen, born, raised, educated, and spending his life in the land of his birth, because he was born in Manchuria and lived much of his life outside of Japan.

1978-1980

Judging from the present exhibition, Minol Araki seems to have arrived at his first painterly home in the splashed-ink landscapes of modern China, the earliest of which in the present exhibition date from 1978. The small group of pictures of the same period he terms "abstractions" (plates 55, 56, 57), in contrast, do not seem to have provided him with any well-formed basis for future development, and remain isolated — at least up until the present. The "abstractions" do, however, suggest the breadth of his interests during that interesting and clearly formative time in a life increasingly dedicated to the art of painting. Among the many other types of work that Araki explored in the same period are striking figure paintings (plates 44-50), in styles and techniques loosely based upon such Western artists as Picasso and Ben Shahn, but probably also evolved from early interests in the modern form of traditional Japanese painting, Nihonga, which would become a more and more powerful attraction to him. From this profoundly important period also date his earliest efforts to understand the great Ming Dynasty Loyalist painter and powerful individualist, Bada Shanren (plates 36, 37, etc.).[3] Perhaps in this too Araki was following the suggestion of Chang Dai-chien, who was one of Bada's earliest and most influential champions. Araki's paintings of birds, in any case, are as fresh, vivid, and affecting as any of his works, and one can only regret that he has not painted the subject more often.

What is to be noted about this conjunction of painterly interests in the period 1979-80 is that, at once, altogether, as if they were all pieces of the same whole, Araki was thinking about Chinese landscape painting in the radical "splashed-ink" manner, about highly personal abstract compositions combining color and calligraphy, about emotionally charged strange Chinese birds from a 17th-century "mad" artist, birds depicted as thinking and grieving, and about the many human faces from around the world that appear in his art — faces apparently from Africa,

from Europe, and from Asia. He was thinking too about nude bodies, among which his frank and sensuous *Reclining Nude* of 1980 (plate 49) stands out for its fresh, erotic presence, its elegant calligraphy, and its masterful interplay of black and white shapes.

By this time, Araki had also begun to sketch and paint lotuses, of course, that lovely and inexhaustible symbol of life and death, although the earliest such work in the present exhibition dates to 1986. But it was through his practice of sketching lotuses in Taipei that he came to the attention of Chang Dai-chien. At the same time, perhaps not surprisingly by now, Araki was painting such delightful, vivid, and relatively unmediated scenes from the wide world of his international travels as *Pier* of 1980 (plate 53). *Pier* is painted almost like an English watercolor, as if done freshly and directly from nature.

Having located these quite diverse images within a single two-year period between 1978 and 1980, we may begin to realize how organically and naturally they all appear to relate to one another and to the rich, complex life of the man who made them. Yet as recently as 1980 there appear to have been relatively few indications of the importance that the Japanese art of Nihonga would eventually play in forming what has become Araki's art today.

The Manchurian Connection

As Claudia Brown points out in this catalogue, Araki began to experiment with elements of traditional Japanese art around 1980. Initially these experiments were concerned with format, especially the use of multiple panels based on the Japanese screen, *byobu*, but came to include monumental constructions based upon the traditional measurements of the *tatami* mat. It is interesting that Araki began to explore this module format, and that he found it so much to his liking, because there could not be a more essentially East Asian traditional format than the pictorial module.[4] Yet its use in painting had died out in China and was alive only in the conservative and traditional form of Japanese art, Nihonga. The history of Nihonga in this century is closely bound up with Manchuria and other outposts of the Japanese Asian empire.[5]

But it was not until late in the 1980s that Araki's engagement with Nihonga burst into view with such pictures as *Silent Night* (plate 13), and, in 1992, the ambitious *Snow Monkeys at Play in Autumn and Winter* (plate 54). Like its Chinese equivalent, *Guohua*,

or Chinese-style painting, Nihonga carries a heavy load of nationalistic intimations that extends far beyond the physical, stylistic, or aesthetic attributes of art into matters of national identity and values, of a stubborn opposition to internationalism, and of the rejection of all aspects of modernism, among many other associations. Nihonga has had close and fascinating connections with those who were associated with the Japanese puppet state of Manchuria, like Araki, and with fervent supporters of Japan's fascist military ambitions throughout Asia.[6]

Despite all this, Nihonga has remained throughout this turbulent century perhaps the most esteemed visual manifestation of the highest spiritual and nationalistic values of the Japanese people. So it is not surprising that Araki, having immersed himself in the Chinese traditions received through the accident of his Manchurian birth, and in the European cultures of the modern world into which he found himself transplanted via postwar Japan, turned late in his life to the most idealistic manifestation of modern Japanese culture, Nihonga. He has referred to his monumental *Snow Monkeys at Play in Autumn and Winter* as Japanese monkeys in a Chinese landscape (as noted in Claudia Brown's essay). Perhaps we are looking at monkeys in a Manchurian landscape. In any case, Araki's new Nihonga in a Chinese setting is a conscious blending of Chinese and Japanese elements, something that is of course also intrinsic to the identity of Nihonga throughout its history.

One would think it nearly impossible to reconcile Nihonga, with its nationalistic, conservative history, Picasso, the master of modernism and leader of the internationalization of modern art, splashed-ink landscape painting from China, the intense, troubled passion of the Ming loyalist painter Bada Shanren, and the heavily European Socialist graphic art of such men as Ben Shahn. These appear to be essentially irreconcilable forms of artistic expression, it seems to me. And yet Araki has reconciled them all within the framework of his life and experience. Nor is that by any means the limit of his engagement with the styles and traditions that have formed his life and art.

Fire Island

A small group of pictures by Araki that stands out for its distinctive character can be associated with his visits to Fire Island (see especially plate 52: *Fire Island*). Indeed, these very personal and deeply rooted paintings make a wonderful small

exhibition of their own. Araki here seems to me to come closest to a purely personal and relatively unmediated engagement with the making of images. Similar to the Fire Island pictures in their attainment of these qualities are the lovely, unambitious flower paintings (plates 42, 43) and the quiet still lifes (plate 39, 41). Along with the Fire Island pictures, they reveal the painter at his most intimate and unguarded, thinking visually, reflecting, almost unconsciously recording through his brush the visual experiences of a life of close observation and deep reflection. A related series of paintings depicting the four seasons, not included in the exhibition, remained in my mind long after I saw them.

Mountains and Rivers

Having reviewed the background of Minol Araki's life in art, we cannot fail to observe the overwhelming concentration on one subject above all others and that is, of course, landscape. Rivaled only by the frequency and colorful drama of his lotus paintings, Araki's landscape paintings are the very essence of his achievement in the art of painting. No one who views this exhibition can fail to be impressed with the images of mountains and rivers that fill the walls. The installation evokes the artists of old, who covered their walls with images of the great mountains lying somewhere beyond their physical attainment. Painting distant mountains with his flowing ink wash and brilliant colors, Araki presents us with the gift of the mountains of his mind. This universal traveler carries everywhere within him the "lofty message of forests and streams"[7] that the great masters of the Chinese and Japanese past have celebrated for a thousand years, and it pours from him in such profusion that it can hardly be constrained by traditional limitations of size and format. Recalling the great Song Dynasty poet Su Shi (Su Dongpo: 1036-1101)[8] or the tireless Tomioka Tessai[9] in his irrepressible exuberance, Araki's gift spreads from scroll to scroll, from panel to panel, almost as a kind of life-force that cannot be constrained. Merely to experience it by walking into a room filled with his landscape paintings is to be refreshed and renewed, as if one had taken a slow walk in the mountains. What has flowed ceaselessly from Minol Araki's brush is the essence of the world we live in, the essence of life. And this powerful, energetic force abides not only in the great monumental works that are so dramatic and compelling, but as well on another, smaller scale in the beautiful, atmospherically rich little paintings of forests (plates 10, 11) and in the quiet, white *Snowy Mountains* (plate 24).

What is so admirable about Minol Araki is his willingness to explore all avenues, to walk every road, in his eager devouring of the worlds he has inhabited. One looks at everything he has painted and sees in all of it the searching, examining, keen-eyed gaze of the artist, the painter. How much such painters have taught us about our world! No one is quite like any other, and an artist like Minol Araki, whose life casts its roots deep into many cultures and many geographical regions of the earth, sees his world and ours in a way no other artist of our time has seen it. And it may be that Minol Araki the man and the artist is most accessible and affecting when he is somehow revealed to us apparently alone within the private world he occupies while looking at pale flowers in a field or sitting by the seashore at Fire Island or feeling the chilled, white air of winter hills. He has formed his art from the diverse cultural regions of his life and his mind, and now reflects quietly upon the world we all inhabit.

Notes

[1] For Chang Dai-chien's art and many examples of his splashed-ink or color landscapes, see Shen C.Y. Fu with Jan Stuart, *Challenging the Past: The Paintings of Chang Dai-chien* (Washington, D.C.: Arthur M Sackler Gallery, 1991).

[2] For a general history of this era, see Michael Sullivan, *The Meeting of Eastern and Western Art* (Berkeley and Los Angeles: University of California Press, 1989).

[3] Bada is the subject of Wang Fangyu and Richard Barnhart, *Master of the Lotus Garden: The Life and Art of Bada Shanren (1626-1705)* (New Haven: Yale University Art Gallery, 1990).

[4] The traditional use of modules in Chinese art history is the subject of Lothar Ledderose, "Module and Mass Production," *Proceedings of the International Colloquium on Chinese Art History, 1991* (Taipei: National Palace Museum, c. 1991), part 2, pp. 821-48.

[5] For a broad, recent introduction to Nihonga, see Ellen P. Conant, in collaboration with Steven D. Owyoung and J. Thomas Rimer, *Nihonga. Transcending the Past: Japanese-Style Painting, 1868-1968* (New York and Tokyo: Weatherhill, 1995).

[6] See, for example, Mimi Hall Yiengpruksawan, "Japanese War Paint: Kawabata Ryushi and the Emptying of the Modern," *Archives of Asian Art*, 46 (1993), pp. 76-90.

[7] *Linchuan gaozhi*, "the Lofty Message of Forests and Streams," is the title of an essay on landscape painting written by the Song landscape painter Guo Xi (c. 1010-c. 1090).

[8] Su Shi's ebullient life and art are the subject of Ronald C. Egan, *Word, Image, and Deed in the Life of Su Shi* (Cambridge: Council on East Asian Studies, Harvard University Press, 1994).

[9] Tessai's life and art are included in the recent catalogue of Nihonga, cited in note 5.

THE PAINTING OF MINOL ARAKI AND THE LOTUS IN CHINESE CULTURE

Steven D. Owyoung

Introduction

The palette and style of Araki's paintings of the lotus, one of the major themes in his work, are quite distinct from his other renderings of flowers and fruit. In 1991, the artist painted *Lotus Pond* (plate 33), a horizontal work that depicts the lotus plant's luminous blossoms, dark leaves, and slender stalks. The breadth of the painting embraces the natural profusion of the lotus's growth and the close and shadowy press of the large, hovering leaves that seem barely tethered by their long curving stems. Created with ink washes of various gradations, the leaves are slightly colored with overlays of blue-green. Furled leaf buds hang pendant, nearly expectant and predatory, the dense layering of full leaves reaching into the distance, floating kite-like and filling the air. Massing dark in the foreground, they grow faint and appear diffuse as if by dint of light and space. From underneath, the lotus blossoms glow radiantly white and flushed pink, their petals pointed and sharp against the amorphous shapes of the ink leaves. The buds, both closed and newly opening, arise compact and thrusting through; the overblown flower, petals in disarray, reveals its naked seed pod.

With *Lotus Pond*, Araki evokes the humid and damp environs so suitable and natural to the lotus. Native to the Chinese south, the lotus (*Nelumbo nucifera*) grows in a warm and temperate region of many fine flowing rivers and scenic lakes. Universally admired for its beauty and lush verdure, the lotus was transplanted throughout China, and everywhere the blooming of the lotus commonly summons the feeling of languid summer, rich and opulent; the warm and humid days and nights filled with the fragrance of the blossoms even from afar.

The theme of the lotus first appeared in the art and poetry of ancient China. It then became one of the most prominent images in Asian art, with a particularly long, vibrant history in Japan as well as China. In the modern era, the painter Chang Dai-chien (1899-1983) expanded and enriched this tradition to encompass both the ornamental and expressive characters of the lotus theme. A genius of technique and a creative master, Chang painted the lotus in a wide variety of styles, from the very finest decorative modes to the most powerful and compelling ink painting of his generation. His influence can be seen in the work of a number of living artists, among them Yang Yanping (b. 1934) and Chen Jialing (b. 1937), who are noted for their paintings of the lotus.

Araki, however, stands alone among this generation of artists. He and his paintings are not only directly inspired by and intimately linked to Chang Dai-chien in style and tone but also partake of the master's deeper understanding and appreciation of the lotus in traditional Chinese culture. While rendering the

beauty of the lotus flower, Araki reveals as well its historical and philosophical foundations, an extraordinarily rich and complex font of love poetry, religious imagery, and Confucian morality. And so it is in the context of the lotus within Chinese art and literature that Araki's paintings must be seen.

The Lotus in China

In its native south, the lotus grew abundantly and had many uses. Its stalks and stamen were believed to have medicinal properties, and in times long past select parts of the flower were applied as a cosmetic. The lotus was also cultivated for its edible, tasty seeds and roots. Fresh seasonal offerings of food to the imperial household traditionally included lotus seeds in the sixth month, and among the notable epicurean delights of the south was the lotus root of Nanjing, a tuber the size of a man's arm, but crisp and sweet.[1]

The earliest mention of the lotus in China occurs in the venerable classic *Book of Songs* of the 12th-7th centuries B.C., where the flower appears amid the verses of southern airs, the simple but emotive *nan* poems related to the ducal states of the Zhou royal house:

> ...By that swamp's shore
> Grow reeds and lotus-flowers.
> There is a man so fair-
> Well-made, big, and stern.
> Day and night I can do nothing;
> Face on pillow I toss and turn.[2]

Although descriptive of the watery environs of the south, the poem also closely intertwines the lotus to romantic attraction and amorous distraction. In the art of the Spring and Autumn Period, the inherently regional character of the lotus is revealed in the flamboyant openwork decor of ceremonial bronzes influenced by the exuberant culture of the powerful State of Chu far to the south of the metropolitan centers of the Zhou kings in central China. It was in the kingdom of Chu that the hapless aristocrat and courtier Qu Yuan (340?-278 B.C.), was slandered by his enemies and became estranged from his king. His poem "Encountering Sorrow" was written in protest and despair. Clothing himself in the lotus as a sign of his loyalty and purity, Qu Yuan laments:

> I made a coat of lotus and water-chestnut leaves,
> And gathered lotus petals to make myself a skirt.
> I will no longer care that no one understands me,
> As long as I can keep the sweet fragrance of my mind.[3]

As a romantic image, the lotus was further developed in the Three Kingdoms and Six Dynasties periods, most notably in the odes and poetry associated with imperial literary circles. In *Goddess of the Luo River*, Cao Zhi (192-232 A.D.), the Prince of Chen, recorded an imaginary encounter with a water spirit and described her beauty in floral terms: "Now near, she glistens like a young lotus, a bud new-risen above the waters of the lake."[4] The Xiao family emperors of the Liang dynasty were exemplary patrons of literature, building vast libraries and supporting many famous poets at their courts. The emperor Xiao Gang (503-551), credited with the development of a new kind of expressive love poem called Palace Style Poetry, wrote of the gathering of lotus flowers in a poignant and evocative poem called "Picking Lotus Blossoms":

> Late sun lights the empty jetty
> We gatherers of lotuses continue by favor of the evening glow
>
> The wind rises and the lake is hard to cross
> So many lotuses, undiminished by the harvest
>
> The oar rows and the petals fall
> The boat sways and the white egret takes flight
>
> The lotus silk passes by, entwining about our wrists
> The water caltrop keeps pulling at our gowns[5]

Such layered sentiments of tender love and ephemeral, even divine beauty in court poetry were influenced by the works of the highly skilled, professional courtesans of the Eastern Jin, from around the 5th century. Direct and baldly descriptive, verses from the pleasure quarters speak of earthly longing and more worldly encounters, such as those found in *The Songs of Ziye*:

> Green lotus leaves, a canopy on the pond.
> Each lotus flower conceals a ruby crown.
> The gentleman longs to pluck me off.
> But my heart yearns for the lotus seed.[6]

With the introduction of Buddhism and its sacred art and scripture to China, the prominence and popularity of the lotus as a theme and symbol increased, aided by early 5th-century translations from Sanskrit of the *Amita Buddha* and *Buddha of Measureless Life* sutras, which described spiritual rebirth and absolute enlightenment in a heavenly Pure Land filled with lotuses of many colors. *The Lotus Sutra* itself proclaimed the miraculous transformation of the daughter of the dragon king who proceeded "to the Spotless World of the south, taking a seat on a jeweled lotus, and attaining impartial and correct enlightenment," and becoming a Buddha before a skeptical but multitudinous host of deities and demigods.[7]

From the Tang dynasty onward, the religious and secular representation of the lotus continued to coexist throughout later Chinese history. Timeless Buddhist deities sat upon great lotus thrones of marble and fragrant woods in tranquil temples, while in the palaces and gardens artificial lotus blossoms of fine, gauze silk bobbed upon the coiffeurs of court ladies as hallmarks of high but fleeting fashion.

By the Song dynasty, even staid Confucian scholars had succumbed to the perfection of the lotus, and they sought to represent the flower as emblematic of the true gentleman. The humanistic ideal was most famously expressed by Zhou Dunyi (1017-1073), a Northern Song scholar known for his redefinition of the Confucian cosmology and metaphysics. In an essay entitled "On the Love of Lotuses," Zhou praised the lotus and imbued it with Neo-Confucian virtues, expanding the role of the flower beyond its previous symbolic imagery among poets, artists, and Buddhists.

> Among flowering plants in water or earth, there are many that are admired. During the Jin dynasty, Tao Yuanming cherished only the chrysanthemum. And since the Tang dynasty of the imperial Li family, everyone has been enamored of the peony. But I especially love the lotus, for it rises from the muck unstained; bathed in clear rippling water, yet not wickedly seductive. The center of its stem is unobstructed and clear; outside, it is straight, not ten-drilled nor branched. At a distance, its fragrance becomes all the purer. In elegantly erect and uniform plantings, the blossoms are for enjoyment from afar, but not for intimate dalliance. I call the chrysanthemum the recluse of flowers; the peony, the wealthiest and noble of flowers. But the lotus is the gentleman of flowers. Alas, for admirers of the chrysanthemum, after Tao Yuanming they are seldom known. But for love of the lotus, who can ever match me? As for devotees of the peony, it is surely no wonder there has been such a crowd! [8]

The lotus and its figurative character in Chinese culture was further enhanced by common custom and decoration. Folk festivals and calendrical observances marked each phase of the lotus's growing season, from the unfurling of its leaves in spring to the harvest of its roots in autumn. One of the most charming and oldest lotus celebrations was held for more than seven hundred years, from at least the Song dynasty down to the late Qing. Beginning at twilight around the Double Seven Festival on the seventh day of the seventh lunar month, small children dressed in their finest clothes ran about town, waving lotus leaves[9] illuminated with candles and swinging lanterns of paper lotus blossoms, chanting:

> Lotus-leaf candles! Lotus-leaf candles!
> To-day you are lighted. To-morrow thrown away! [10]

Endearing and delightful, the image of a chubby child holding a lotus flower or leaf became a minor but distinct subject in Chinese art,[11] illustrating the notion that the lotus was a symbol of fertility: in nature, the blossoming flower reveals a prominent pod, and its numerous seeds represent a promise of the early arrival of children and the abundance of offspring.

Popular culture, fond of puns and joyfully exploiting the rich homophonous nature of the Chinese language, further imbued the lotus with auspicious meanings, founded on two words for lotus, *lian* and *he*, and also *ou*, its root. Thus, the motif of a boy holding a lotus, which was based on the candlelight parades of the Double Seven Festival, was a wish for *lian*, continuous male progeny.[12] *Ou*, the lotus root, was a play on the word for spouse,[13] whose union or *lian/ho* with wife or husband ideally produces *he*, harmony in marriage. *Lian* was also an ancient word for love,[14] and the lotus in painting came to symbolize marital love and a blissful marriage.

During the Five Dynasties period (907-960), there developed antithetical traditions of flower painting, which were based on the personal styles of two 10th-century painters, Xu Xi and Huang Quan. The bold and free flower painting style of the Jiangnan scholar Xu Xi developed contemporaneously with the fine and subtle works of Huang Quan, but represented an entirely different approach. Far from delicate or meticulous, Xu Xi preferred a vigorous and somewhat physical kind of painting that employed a rather wild and brusque style, using ink and colors without line. A literatus who eschewed the restricted life of an official, Xu Xi ignored the niceties of outward appearance and strove to represent the essence of the flowering plant. The Song emperor was so impressed by the artist's bold, free paintings that he promoted Xu Xi's style as an artistic and methodological model for the palace academy,[17] Although the emperor's efforts were unsuccessful, Xu Xi had provided an alternative to artists, especially the literati who sought to capture and reveal the natural essence of things and who keenly appreciated the expression of self.

The flower paintings of the Sichuan court artist Huang Quan were widely appreciated for their delicacy and careful detail, all wrought with lifelike fidelity in a technique of fine outlines filled with color. Later manifestations of the meticulous Huang Quan tradition included "boneless painting," in which outline was subordinate and obscured by precise washes and subtly applied colors.[18] Although he was active as a Song court artist

for only a few short years, Huang Quan's precise, lovely style and realistic representation had a profound and lasting influence on the painting of the imperial academy, whose popular and later heirs included the professional artists of Piling and their rare and beautiful lotus paintings.

From at least the 13th century, paired scrolls of lotuses and mated waterfowl were painted as presents to newly married couples. According to custom, the doubling of pictures and motifs was thought to be exceptionally felicitous. Paintings of this kind were created by the professional artists of the Piling tradition, a group of family studios centered around modern Changzhou in Jiangsu that for generations specialized in highly decorative bird and flower paintings of extraordinary subtlety and sophistication.[15] Although commonly employed as congratulatory nuptial paintings, the solely secular nature of Piling lotus paintings is complicated by the few extant pairs which survive in temple collections in Japan, where double lotus scrolls are believed to represent portions of Amita Buddha's heavenly Pure Land.[16] In any case, all of the existing early Piling lotus paintings, whether pairs or single scrolls, are likely to be late Song or early Yuan dynasty works from the latter part of the 13th century or later. Moreover, regardless of their iconographical significance, the Piling lotuses are indicative of the profound influence of Song academic art on the flower painting genre.

The lotus in Chinese history thus embodied a plethora of cultural meanings from antiquity to recent times. At its simplest, the lotus was a beautiful flower worthy of comparison to the handsomest man or most desirable woman. In the political realm, the lotus signified the loyalty and princely conduct of a true gentleman grounded in the ethics and morals of Confucius. The poets equated the blossom with earthly love, while sacred Buddhist scripture described the lotus as Perfection incarnate, reflected in heavenly treasure ponds filled with lotus seats of rebirth and enlightenment. Among the people, the lotus stood for a happy married life blessed with many children, an auspicious image that decorative artists painted as double scrolls and craftsman carved in jade as tokens between husband and wife. With such a wealth of symbolism, it is no wonder that the lotus remained a favored flower in Chinese art and culture for over four millennia.

The Lotus Paintings of Minol Araki

> Since I recently dug a level pond
> about a hundred *mu* in size,
> I'm waiting for the autumn floods
> to reach the infinite sky;
> When the myriad blossoms of lotus
> open in all their radiance,
> This is where I'll worship Buddha.
> under the southern heaven.[19]

Chang Dai-chien's poem was written during the construction and planting of Mount Mojie, the artist's garden residence in São Paulo, Brazil. In 1961, he excavated Bade, a large lake, and planted it with lotus. Chang Dai-chien's names for both the garden and lake are laden with Buddhist references, particularly Lake Bade (Eight Virtues), taken from a Pure Land sutra that describes a treasure pond in Amita Buddha's Western Paradise.[20] His fascination with the lotus reflects not only the traditional position of the flower in Chinese culture but also its deeper Buddhist significance. As an artist, Chang Dai-chien had been exposed to the lotus's religious and decorative uses during his studies of the Buddhist murals at the Dunhuang Caves in 1941-43 and of copies of wall paintings at Yunlin. Chang depicted lotuses throughout his long life, but they only began to appear with frequency in his work from the late 1940s until his death in 1983.

Although Chang Dai-chien painted the lotus in many ways, some highly decorative and deceptively appealing, he excelled in ink painting, the bold and free literati style proposed by Xu Xi so long ago. Chang's lotuses of minimal color, which rely on the expressive power of his brush and keen compositional sense, are among his best work and form a great part of his enduring legacy. They are stylistically among the most visually interesting and art historically important paintings in his oeuvre and provide the basis for understanding Minol Araki's lotus paintings.

At a glance, Araki's lotus paintings all seem to be of a single style: monochromatic ink paintings with little color and of varying dimensions and compositions. Even the subject, in all of its variations, is limited in the shapes, forms, and textures related to the living plant. Stylistically, Araki could have followed Chang Dai-chien and explored the lotus in its fine and purely decorative forms; but initially he did not. Even the painting *Lotus Pond* of 1991 (plate 33) is only loosely based on Chang's ink painting and follows a variant course of technique and approach. In all, Araki appears to have deliberately chosen a very restrictive manner and subject that necessarily taxes his creative powers and forces the continued exploration of his subject.

In 1992, Araki painted a series of four panels entitled *Lotus Pond* (plate 26), in which the lotus is shown still crowded together, but unlike the 1986 work, there is a bright and airy quality that is supported by the illusion of a gentle breeze shifting the gray, wind-torn leaves in the background. The blossoms too are different in their larger, more opulent size, filling and competing successfully with the leaves for space and light.

The growing primacy of the lotus flower is apparent four years later in the 1996 *Lotus* (plate 31), where the fresh glory of the blossoms contrasts with the decayed, dying leaves that are done in a carefully controlled wash and defined by a drying brush. Even the young, furled leaves of the lotus appear more fleeting and transitory in their bird-swift shapes, readily surrendering to the pure luxury of the bloom. *Lotus* (plate 32), painted in the same year, displays the full flower against a field of blue and gray, the blossom shown clear and unobscured; the single lotus bud on a thin, black prickly stalk is thrust emphatically above and beyond the jungle of the surrounding leaves. The leaves, on the other hand, are subsumed in a formula of similar, stamp-like shapes or as mere color and texture, as in the blue background.

By 1997, the flower took on a different character. Where a year earlier the lotus blossom is open and flat, now the petals are rendered in a dark, gradated ink, in lines that give clear definition and dimension to the lotus flower and its immediate space. Araki's progression is similar to that found in Chang Dai-chien's lotus paintings from 1965 to 1983, where the flower generally gains in refinement, placement, and definition, and by contrast, the leaves of the lotus become less and less distinct. Araki even begins to draw the lotus leaf using the Chang Dai-chien's looping stroke to form sections of a overhanging leaf.

The ultimate abstraction of the leaf form is seen in *Lotus* (plate 34), dated 1997. The composition is absolutely filled with writhing, kinetic forms looming overhead and blocking out everything. Here Araki is at his expressive best and the piercing purity of the lotus flower needs but the barest suggestion to be effective as the kernal of Truth, either Buddhist or Confucian; the wraith-like leaf buds and misshapened leaves add to the mystery and power of the painting. By adopting and making this style of ink painting his own, Araki paints the lotus in a manner that transcends time and paradigm and is directly related to the vigorous, bold literati tradition of the past. With brush and ink, the artist renders a simple flower and reveals its historical roots. It is the age-old search for the essential nature of a thing, a repetitive meditation upon a high symbol and the discovery of the rich and living culture of a grand civilization.

Notes:

1 Gu Chiyuan, *Precious Things* (Zhenwu, 1618).

2 *The Airs of Chen*, no. 145 in Arthur Waley, *The Book of Songs* (New York: Grove Press, 1996), p. 112.

3 David Hawkes, *The Songs of the South: An Ancient Chinese Anthology of Poems by Qu Yuan and Other Poets* (London: Penguin Books, 1985), p.71.

4 Arthur Waley, *An Introduction to the Study of Chinese Painting* (London, 1923), pp. 60-62.

5 Ouyang Xun, *A Categorized Collection of Literary Writing* (Yiwen leiju, 620) (Shanghai: Shanghai guji chuban she, 1982), vol. 2, p. 1401. Many thanks to Dr. Wai-kam Ho for assisting in the translation of this poem.

6 *Tzu-yeh Songs of the Four Seasons*, in Liu and Lo, eds., *Sunflower Splendor*, trans. Michael E. Workman (Indianapolis: Indiana University Press, 1975), pp. 76-77.

7 *Devadatta*, Chapter XII, in Tsugunari Kubo and Yuyama Akira, *The Lotus Sutra* (Berkeley: Numata Center for Buddhist Translation and Research, 1993), pp. 191-98.

8 Zeng Zaozhuang and Liu Lin, eds., *Quan Songwen* (Sichuan: Bashu shushe, 1992), ch. 1073, pp. 263-64. Again, my thanks to Dr. Wai-kam Ho for assisting in the translation of this poem.

9 Meng Yuanlao (fl. 1110-1160), *The Eastern Capital: A Record of a Dream of Flowers (Splendors Past)* (Tong Menghua lu, 1147), Deng Zhicheng, ed. (Beijing: Zhonghua shuchu, 1982), ch. 8, pp. 208-09.

10 Tun Li-ch'en, *Annual Customs and Festivals in Peking*, trans., Derk Bodde (Taipei: SMC Publishing, 1994), pp. 60-61.

11 James C.Y. Watt, *Chinese Jades from Han to Ch'ing* (New York: The Asia Society, 1980), pp. 110-11; Ellen Johnston Laing, "Auspicious Images of Children in China: Ninth to Thirteenth Century," *Orientations*, 27 (January 1996), pp. 47-48.

12 Terese Tse Bartholomew, *The Hundred Flowers: Botanical Motifs in Chinese Art* (San Francisco: Asian Art Museum of San Francisco, 1985), no. 20.

13 Anne Birrell, *New Songs from a Jade Terrace: An Anthology of Early Chinese Love Poetry* (London: George, Allen, and Unwin, 1982), p. 317.

14 Ibid.

15 Shimada Shujiro and Yonezawa Yoshiho, *Painting of the Sung and Yuan Dynasties* (Tokyo: Maruyama and Co., 1952), p. 15; Yoshiaki Shimizu and Carolyn Wheelwright, eds., *Japanese Ink Paintings* (Princeton: The Art Museum, Princeton University, 1976), no. 35, pp. 252-56, 260, nn. 1-4; Toda Teisuke, "Lotus-Pond Paintings," *International Symposium on Art Historical Studies, I, 1982, Kyoto: Flowers and Birds Motif in Asia* (Kyoto: Do Kenkyukai, 1983), pp. 28-32.

16 Sybille Girmond, "The Collection of Japanese Buddhist Painting and Sculpture in the Museum of East Asian Art in Cologne," *Orientations*, 28 (January 1997), p. 50, and Wu Tung, *Tales from the Land of Dragons: 1,000 Years of Chinese Painting* (Boston: Museum of Fine Arts, Boston, 1997), no. 152, p. 236.

17 Richard Barnhart, "Hsu Hsi," in Herbert Franke, ed. *Sung Biographies: Painters* (Wiesbaden: Franz Steiner Verlag, 1976), pp. 41-45.

18 Ibid.

19 Shen C.Y. Fu with Jan Stuart, *Challenging the Past: The Paintings of Chang Dai-chien* (Washington, D.C.: Arthur M. Sackler Gallery, 1991), no. 59, p. 234, trans. by Stephen D. Allee.

20 Ibid., pp. 233-34.

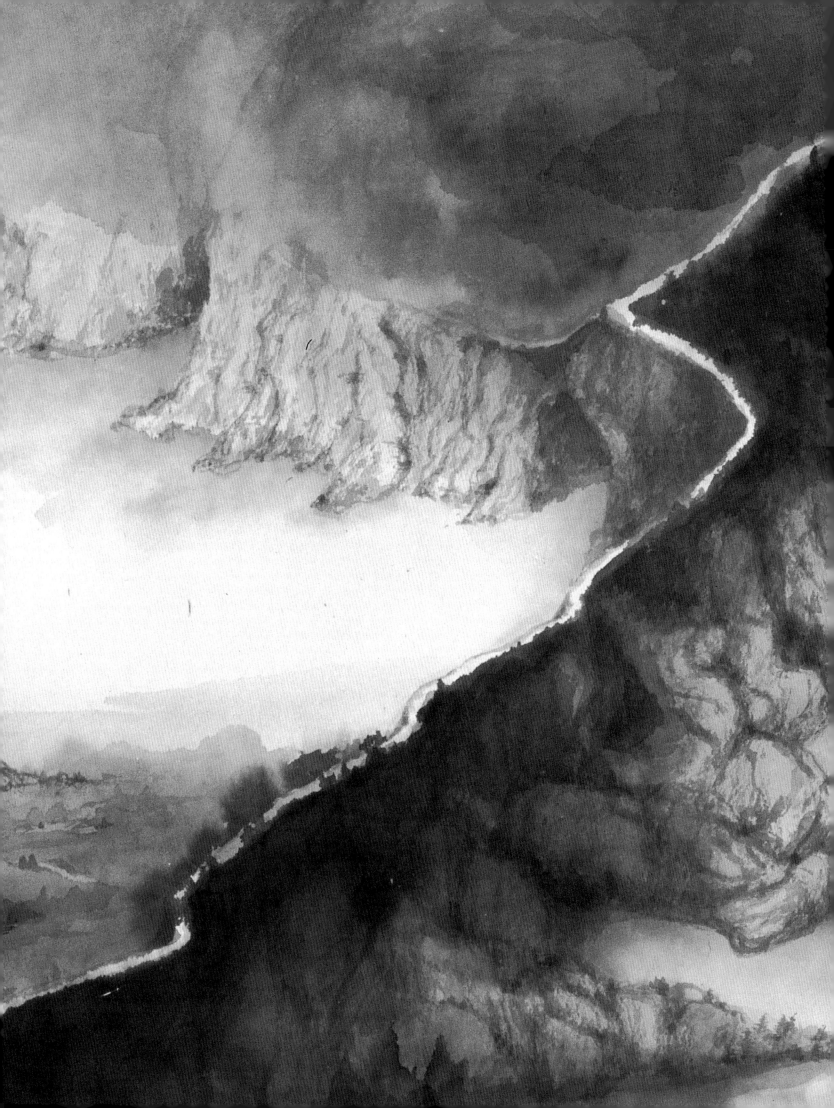

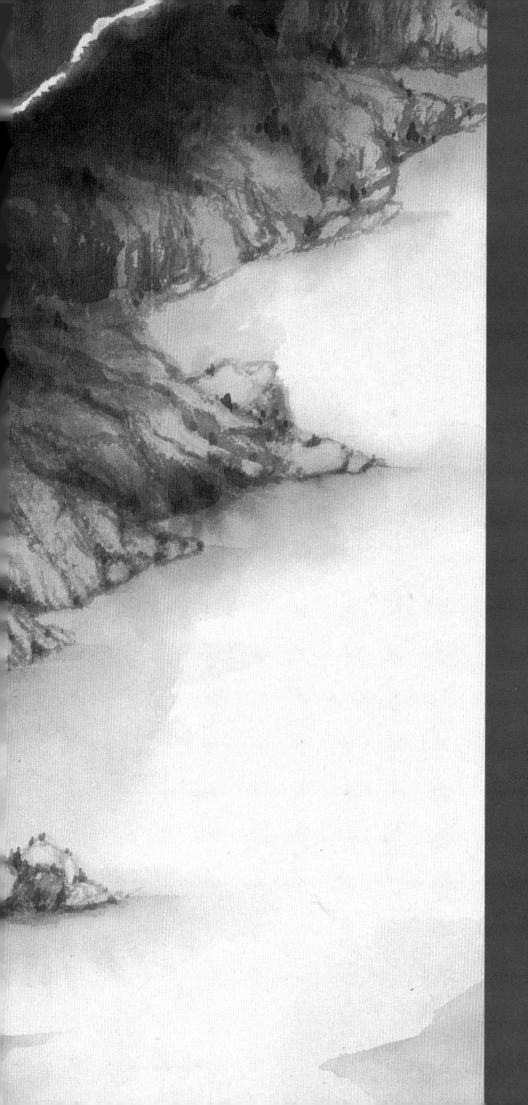

Landscapes

山　水

*When I see the beauty of
mountain landscapes,
I am deeply moved;
my mind is washed pure.*

接觸美麗大自然的風景，
深所感動，心亦能淨靜矣。

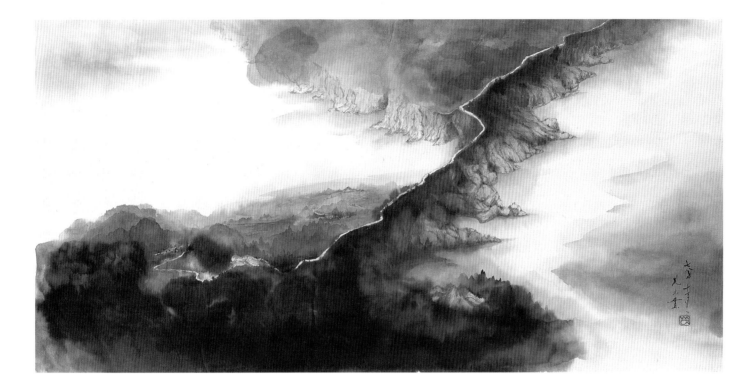

I | DISTANT ROAD
永遠的路

1978
ink on paper, 92 x 187 cm

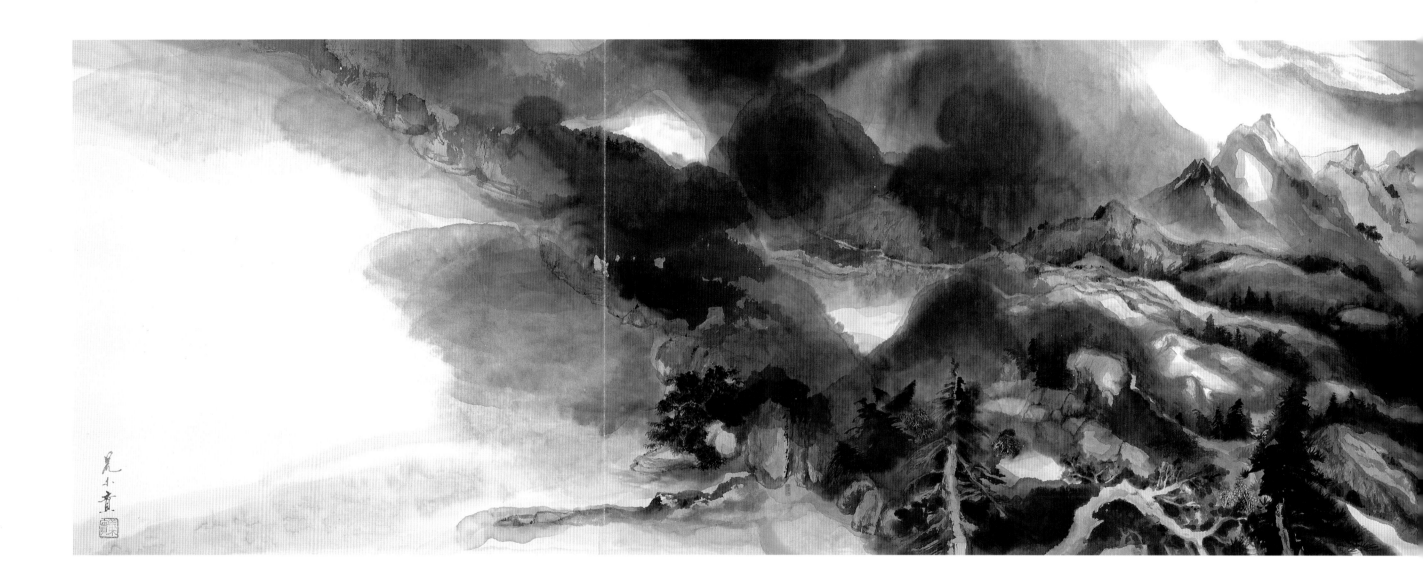

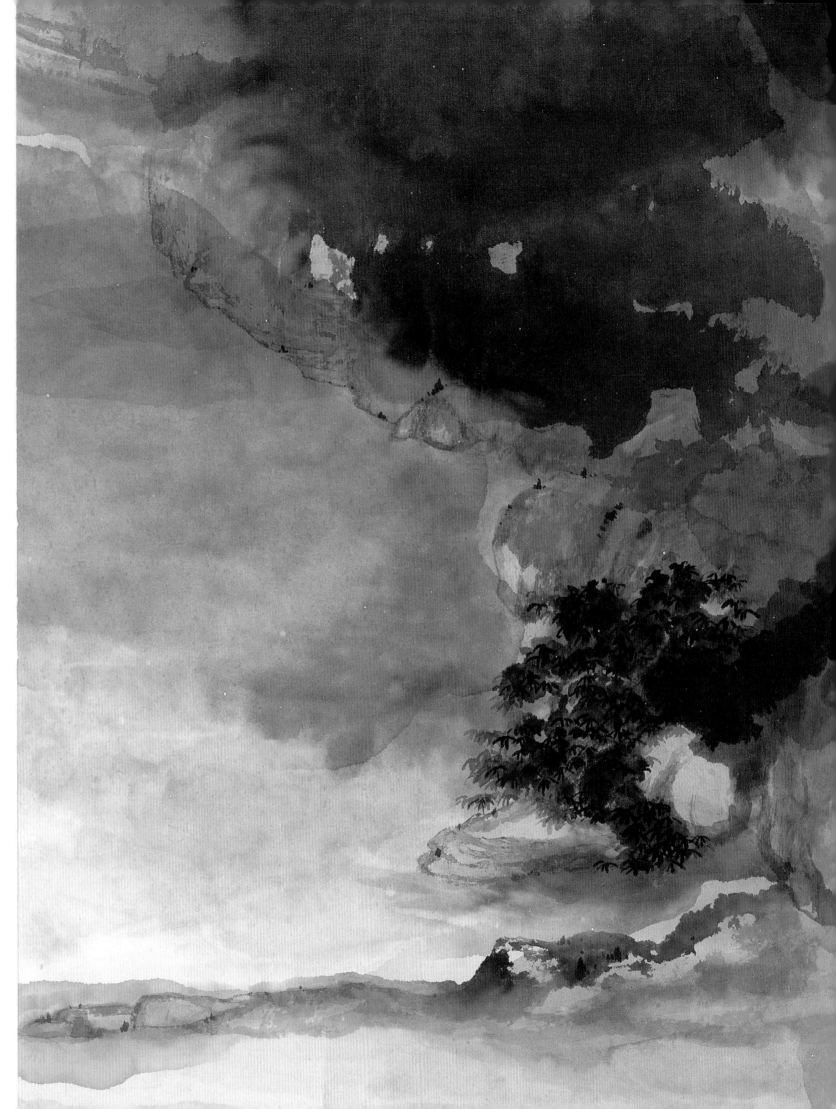

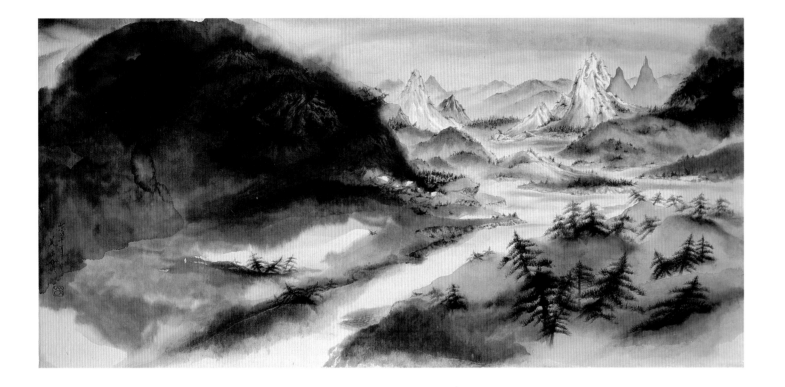

2 | CONTINUOUS PEAKS
連 峰

1978
ink on paper, 93.5 x 178.5 cm

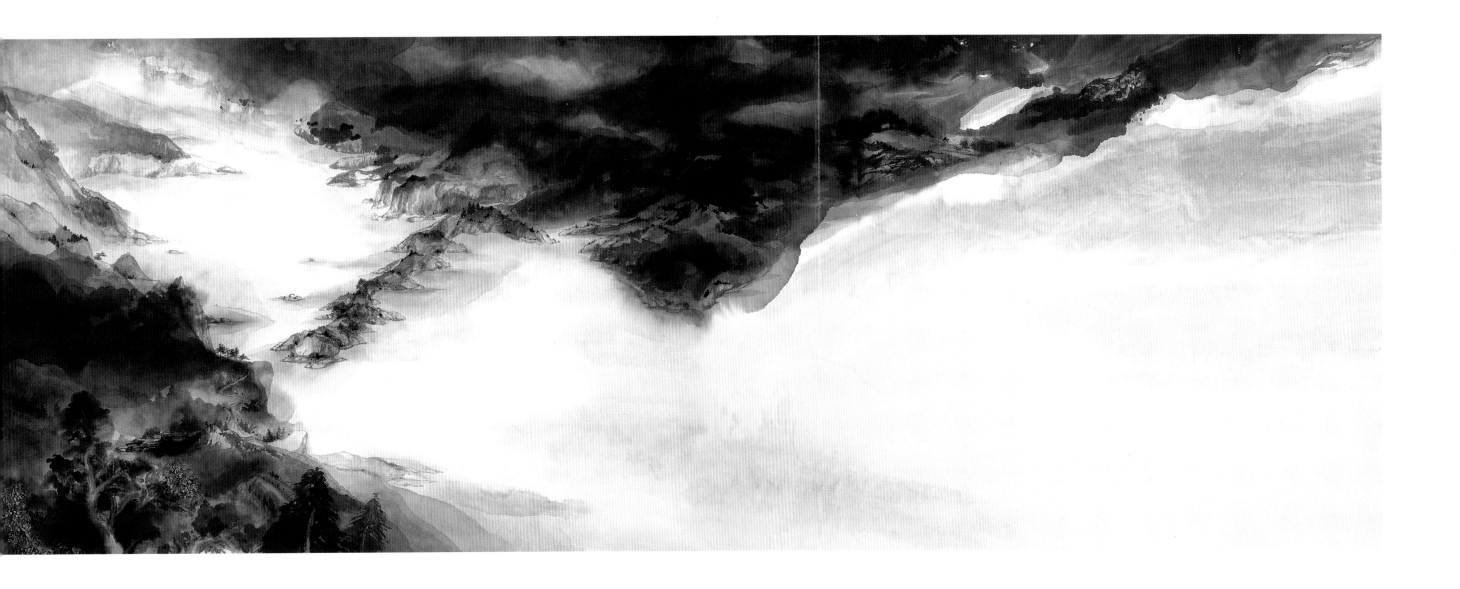

3 DISTANT ROAD II

永遠的路 II

1979
ink on paper, 92 x 512 cm in 4 panels

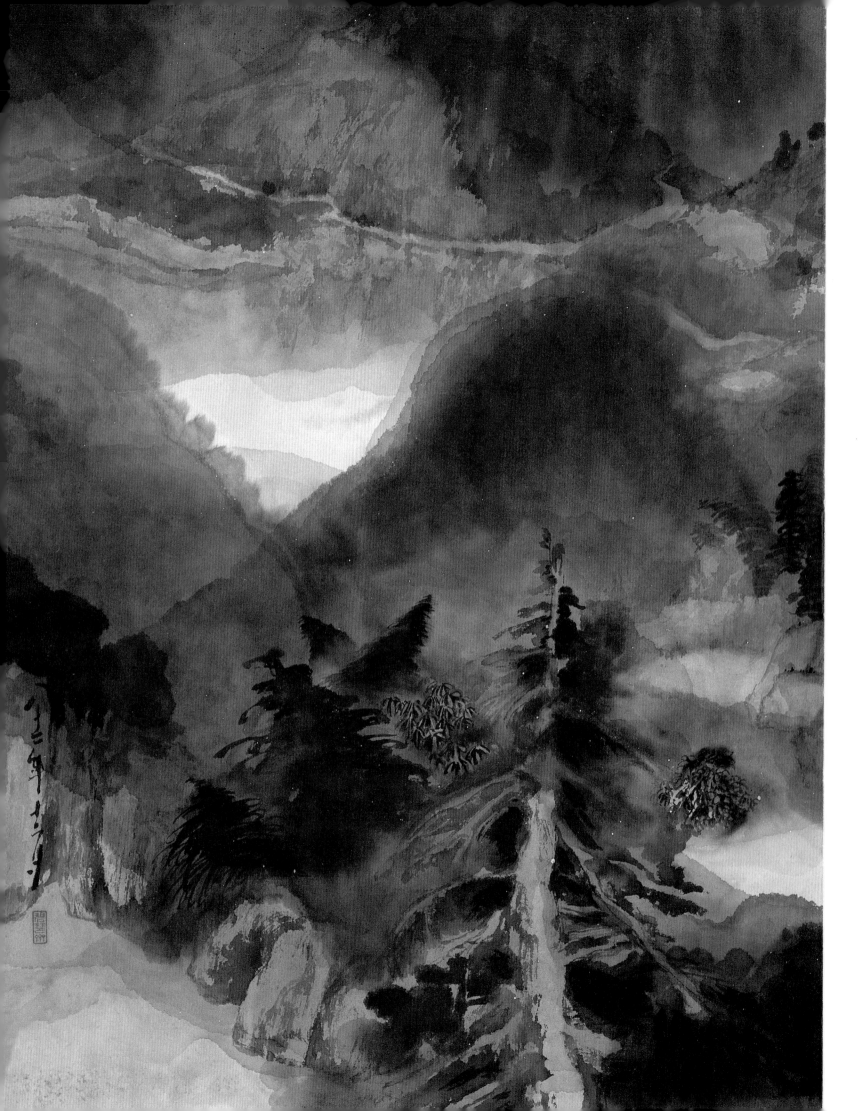

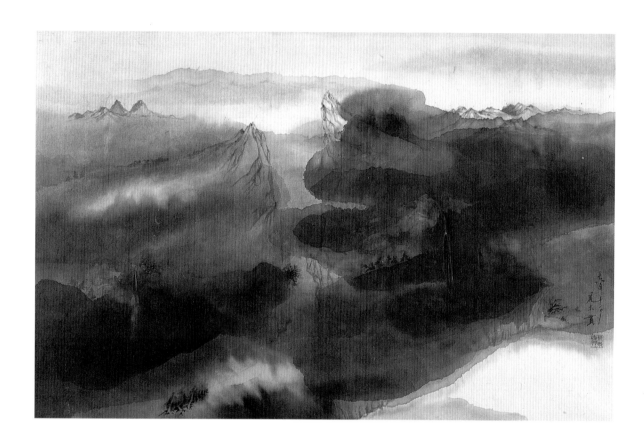

4 | DEEP RAVINE
幽 谷

1978
ink on paper, 62 x 95 cm

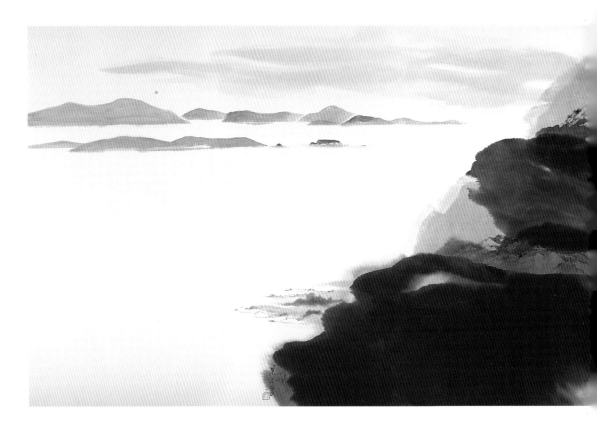

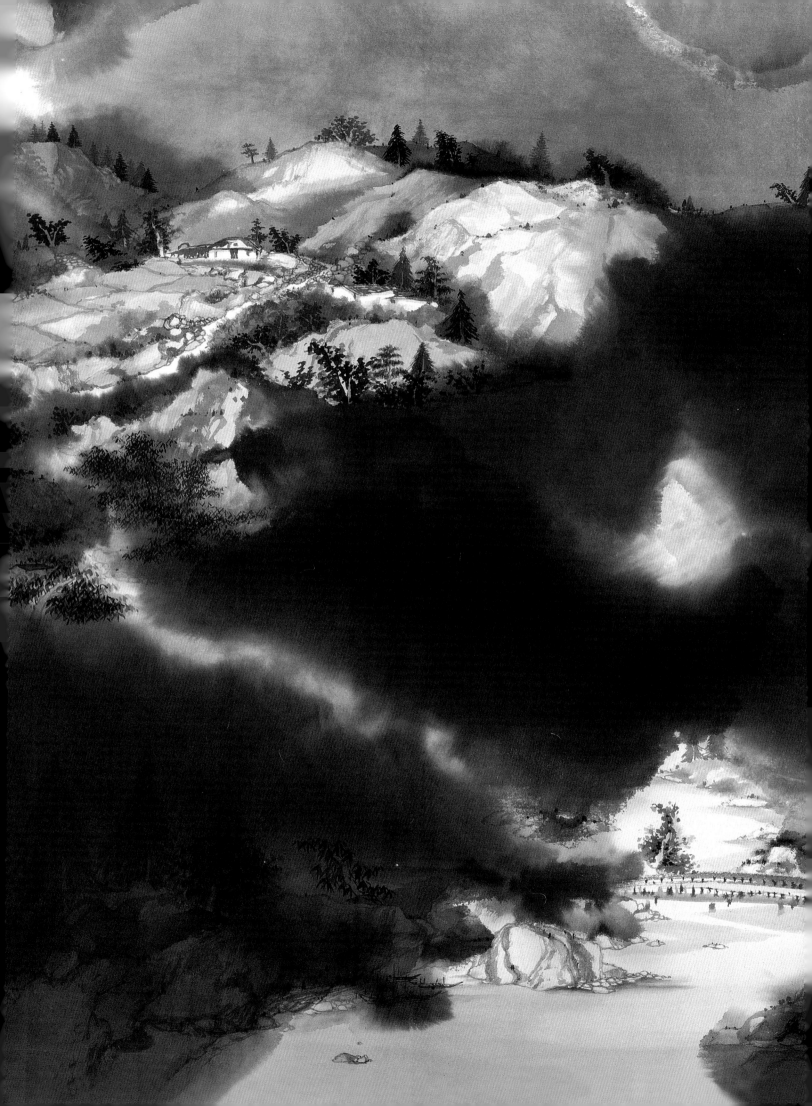

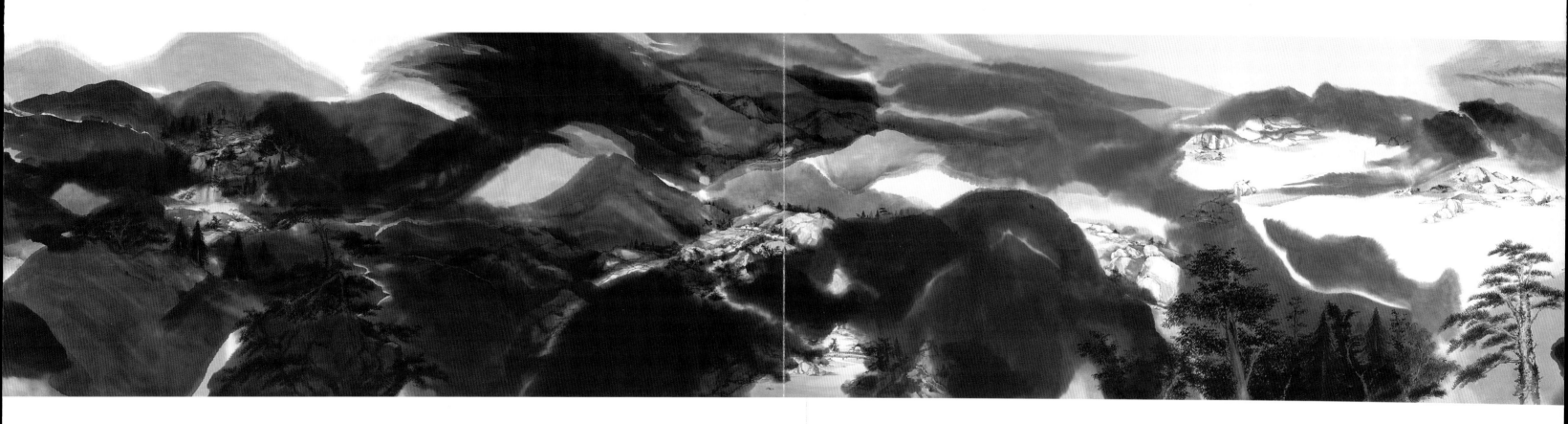

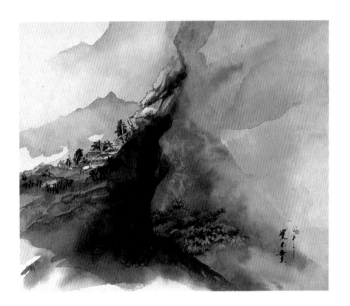

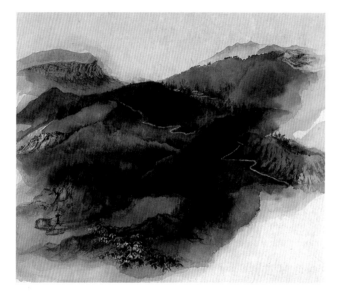

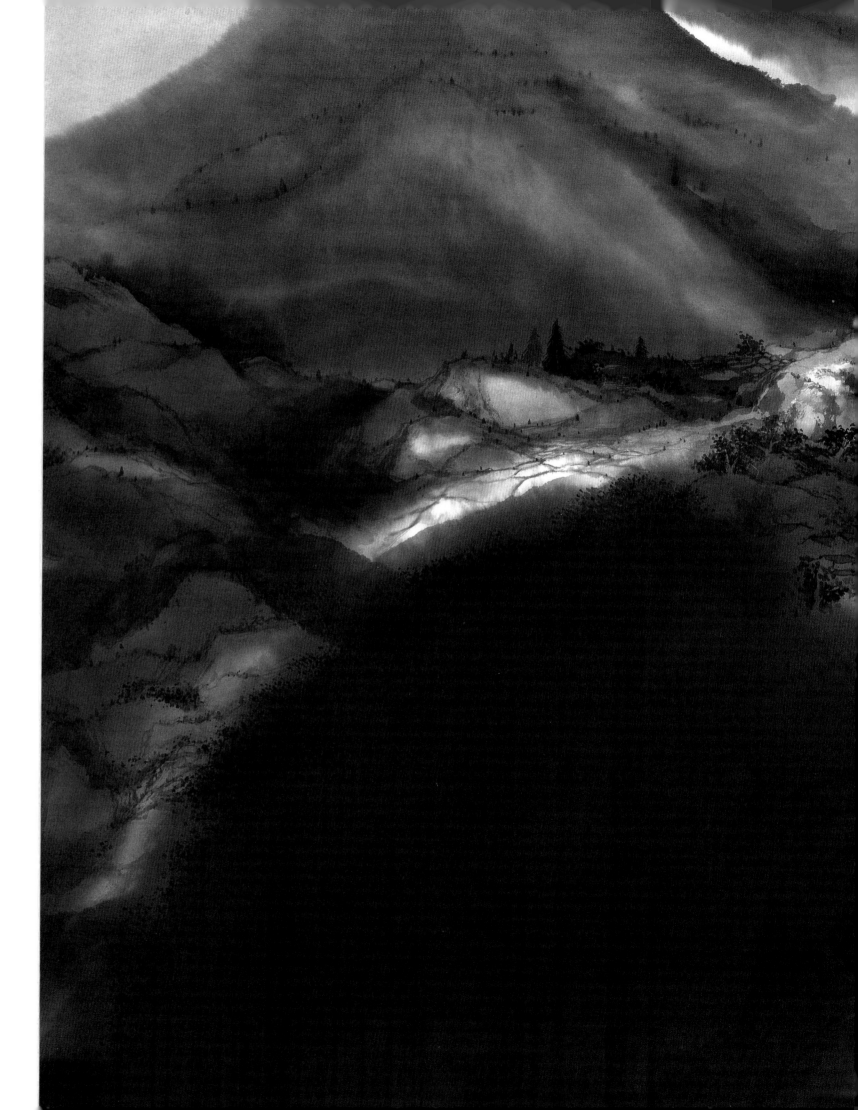

5 | LANDSCAPE
山水

1981
ink and color on paper, 45.5 x 53 cm

6 | LANDSCAPE
山水

1981
ink and color on paper, 45.5 x 53 cm

7 | LANDSCAPE
山水

1981
ink and color on paper, 45.5 x 53 cm

8 | LANDSCAPE
山水

1981
ink and color on paper, 45.5 x 53 cm

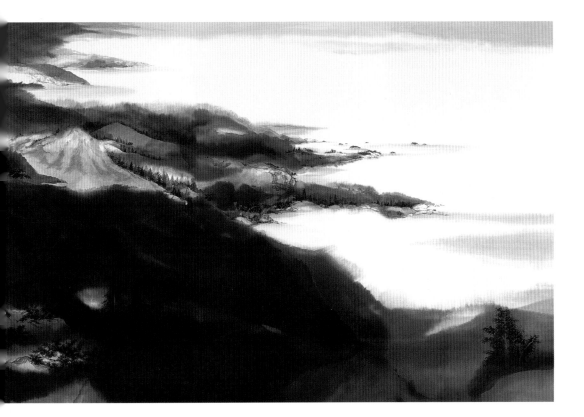

9 | PANORAMIC VIEW OF DREAMY LANDSCAPE
俯嶽夢幻

1980
ink on paper, 176 x 2112 cm in 24 panels

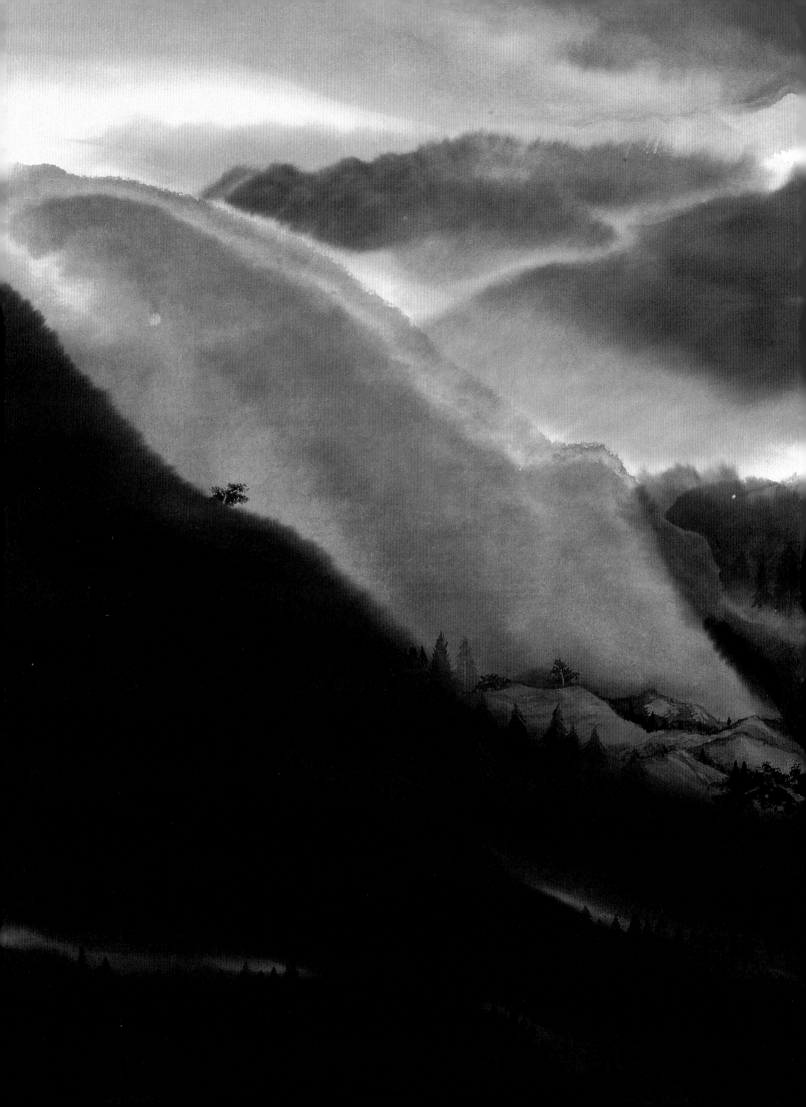

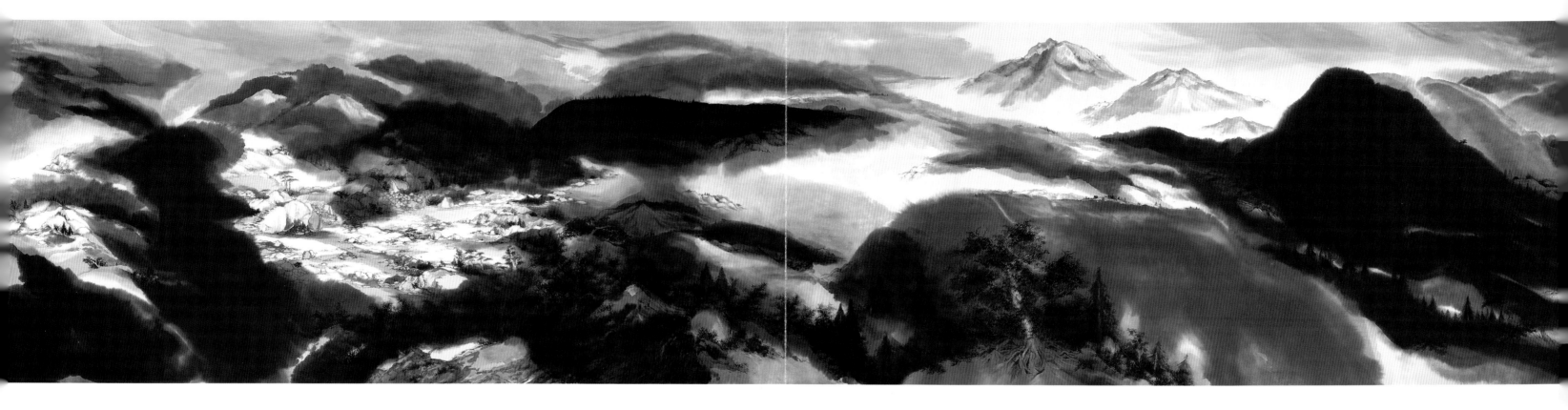

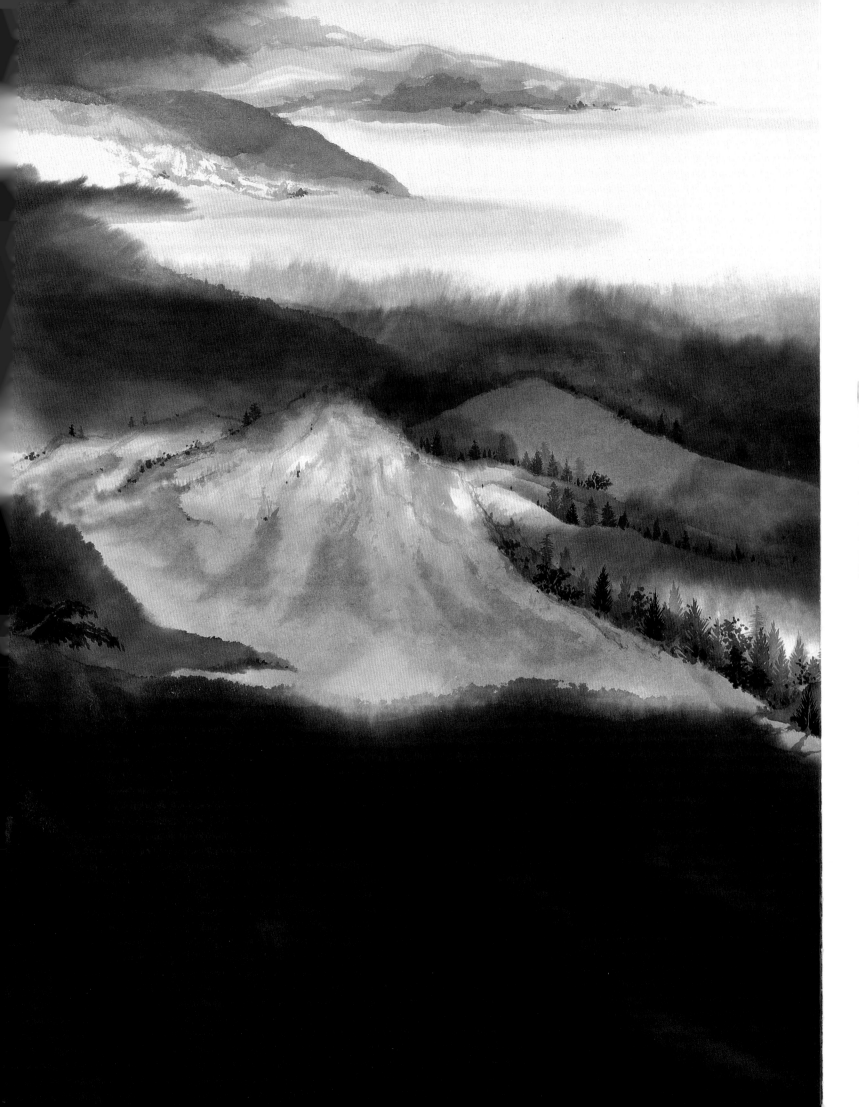

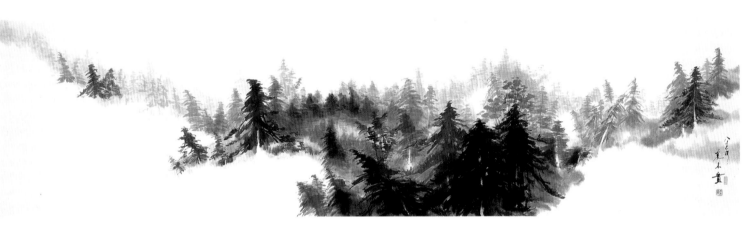

10 | MOUNTAIN FOREST
連 樹

1982
ink on paper, 47.9 x 188.5 cm

11 | ENCROACHING FOREST
樹林

1982
ink on paper, 63 x 96.2 cm

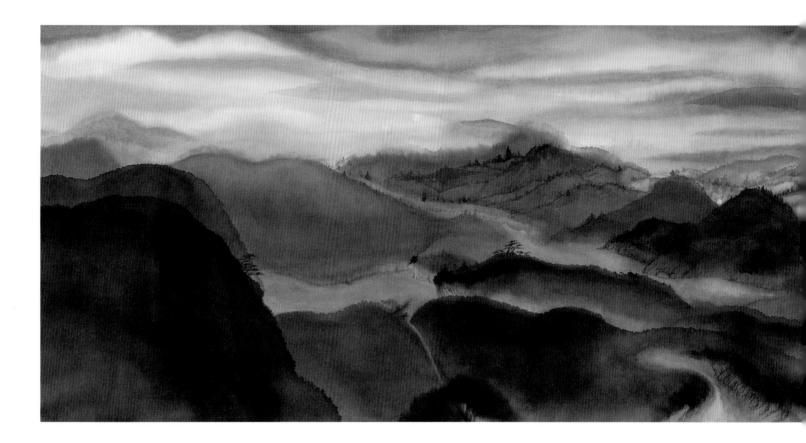

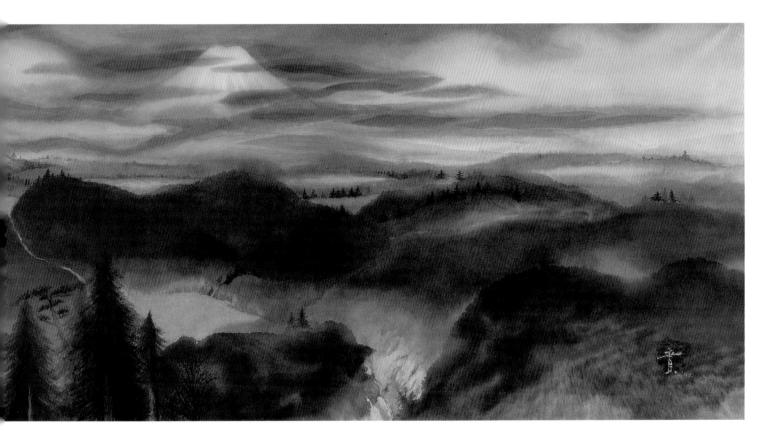

12 | MOUNT FUJI
富士山

1992
ink and color on paper, 90 x 360 cm in 2 panels

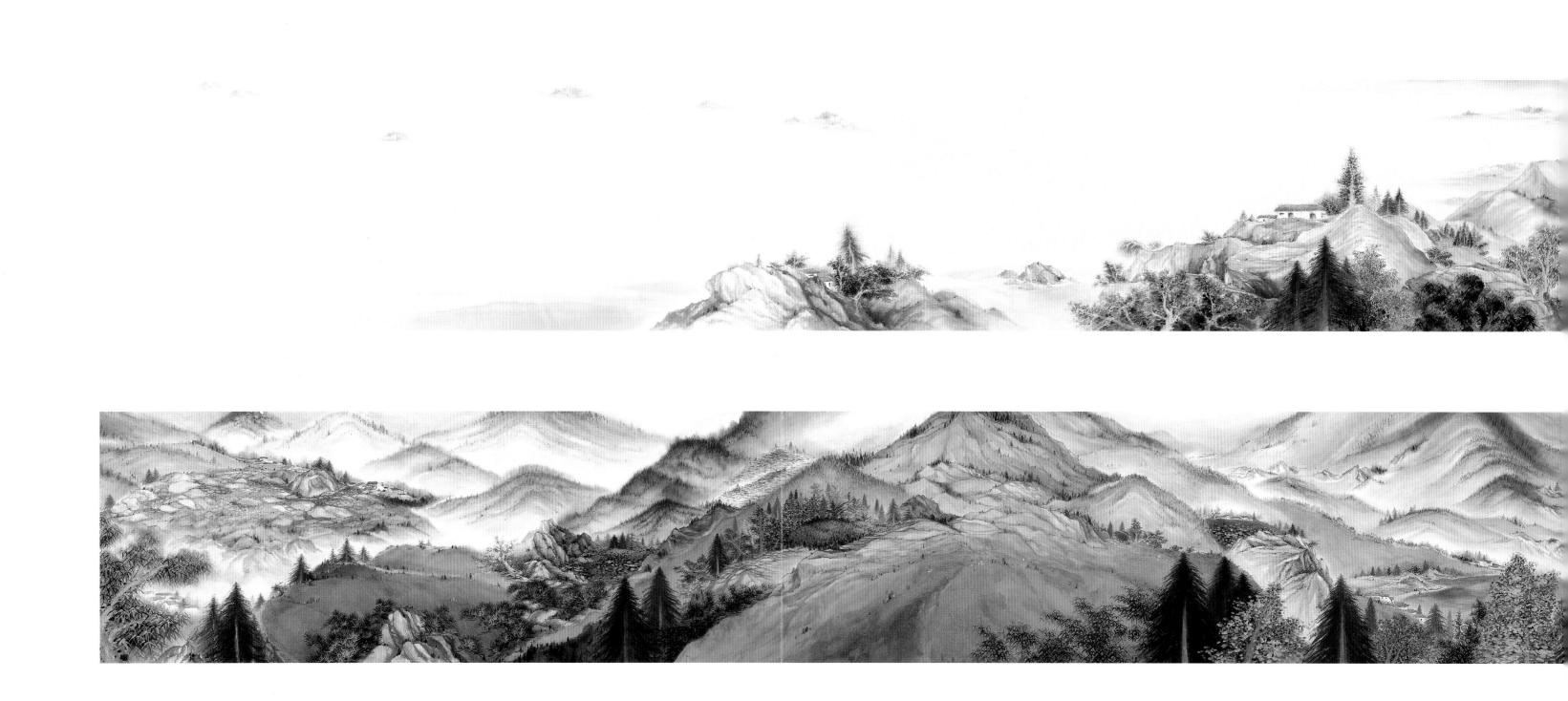

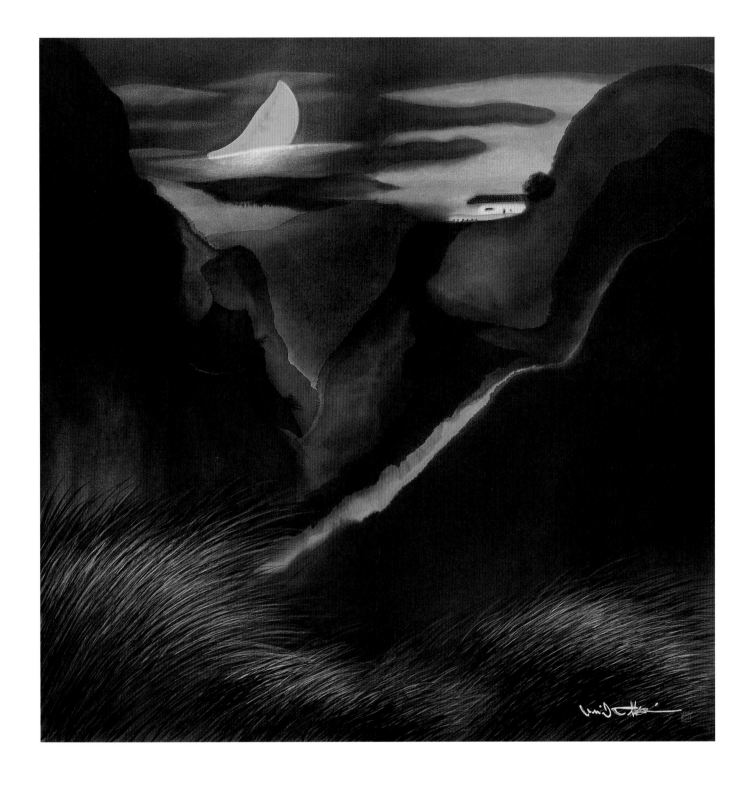

13 | SILENT NIGHT
寂 夜

1989
ink and color on paper, 180 x 180 cm in 2 panels

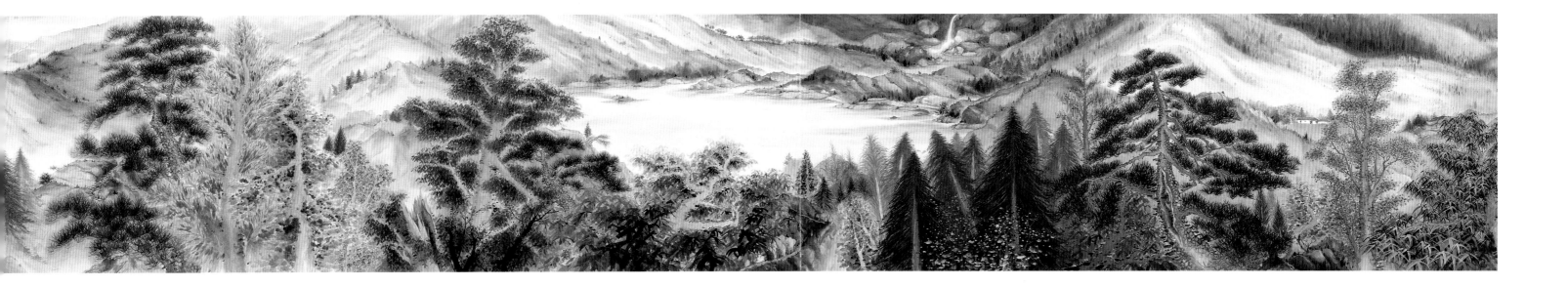

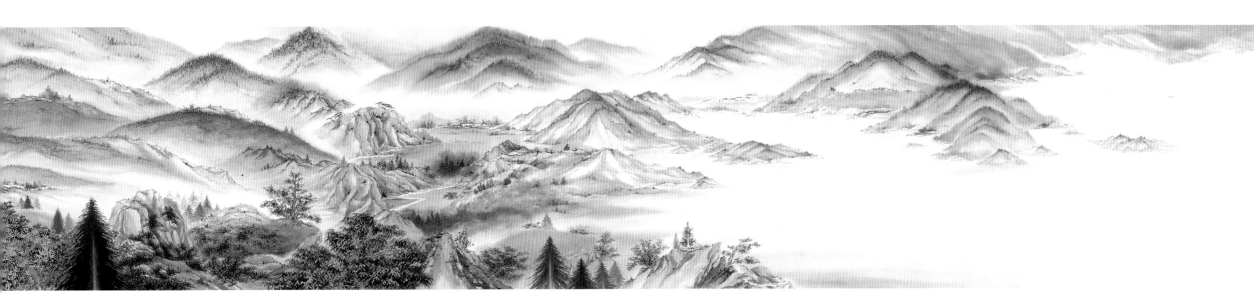

14 | HEKIBA VILLAGE
碧芭村

1985
ink and color on paper, 90 x 2160 cm in 12 panels

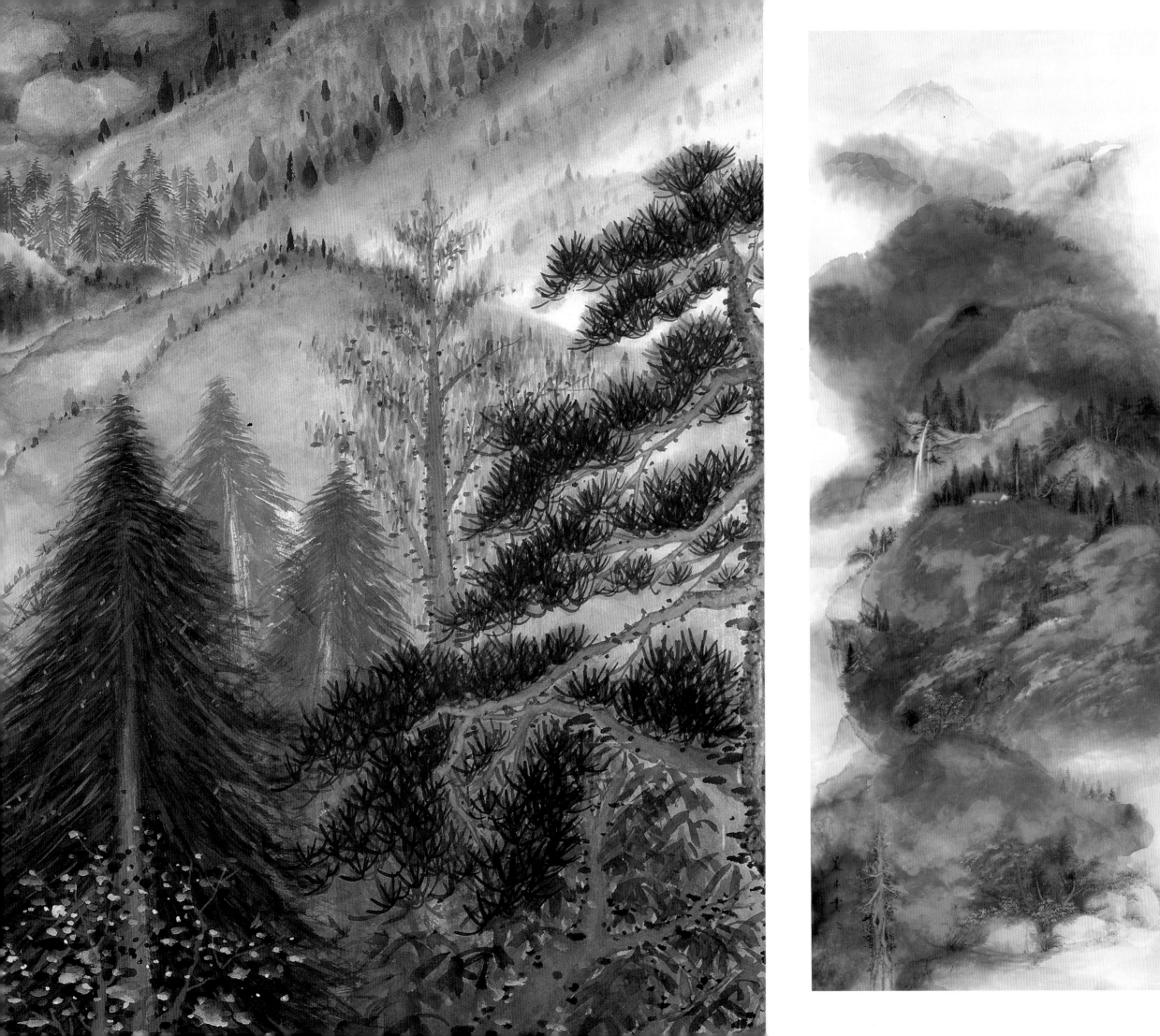

15 | Ethereal Landscape I
仙 峽

1991
hanging scroll, ink and color on paper, 238 x 90.5 cm

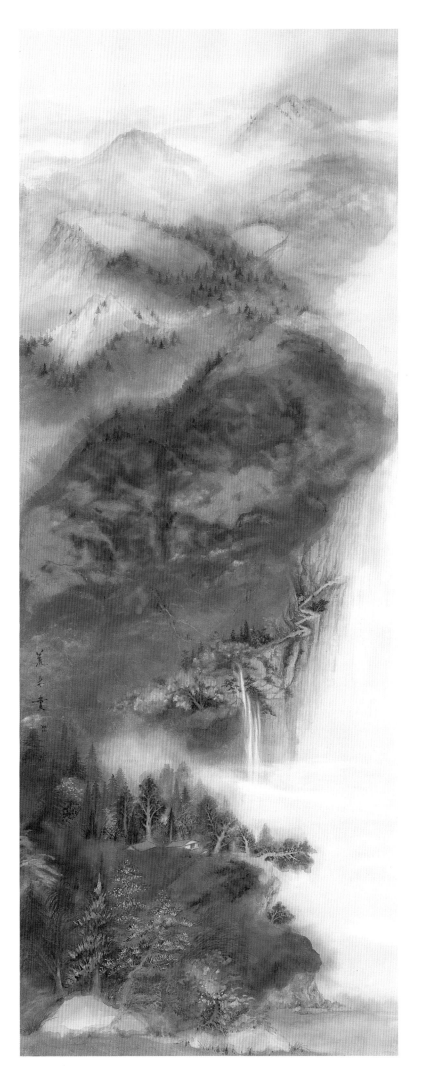

16 ETHEREAL LANDSCAPE II
仙峽

1991
hanging scroll, ink and color on paper, 238 x 90.5 cm

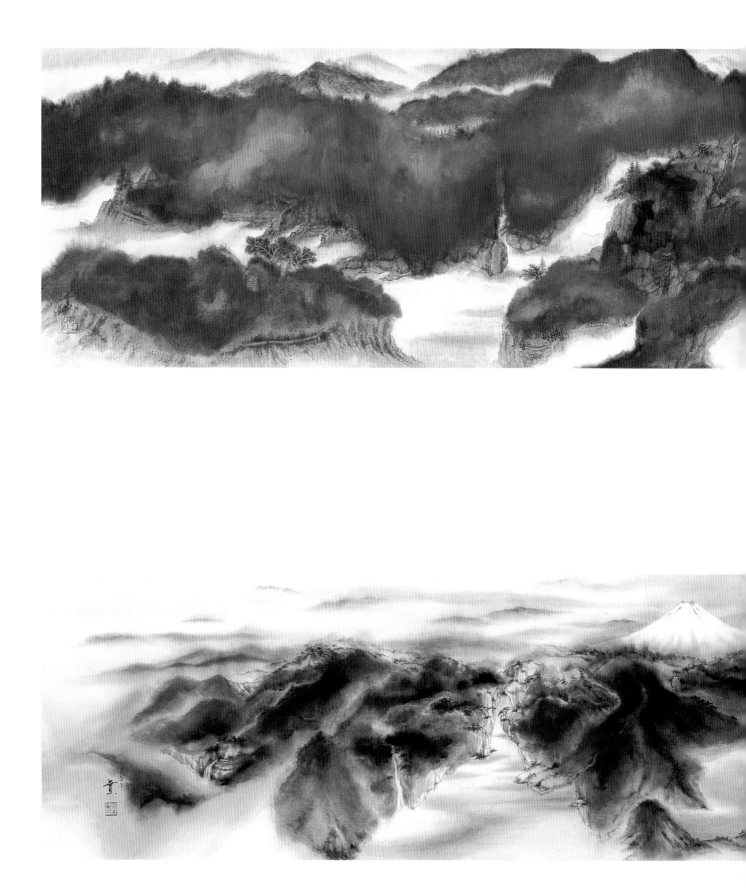

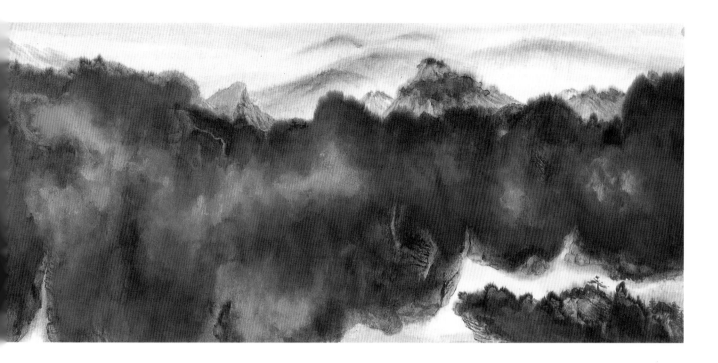

17 | HEKIBA ISLAND
碧芭島

1996
handscroll, ink and color on paper, 47 x 212 cm

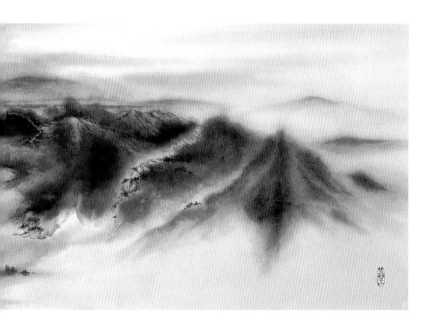

18 | MOUNT FUJI
富士山

1997
handscroll, ink on paper, 45 x 180 cm

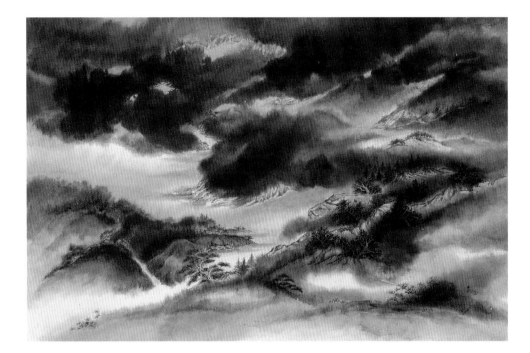

19 | LANDSCAPE
山水

1996
ink and color on paper, 63 x 95.6 cm

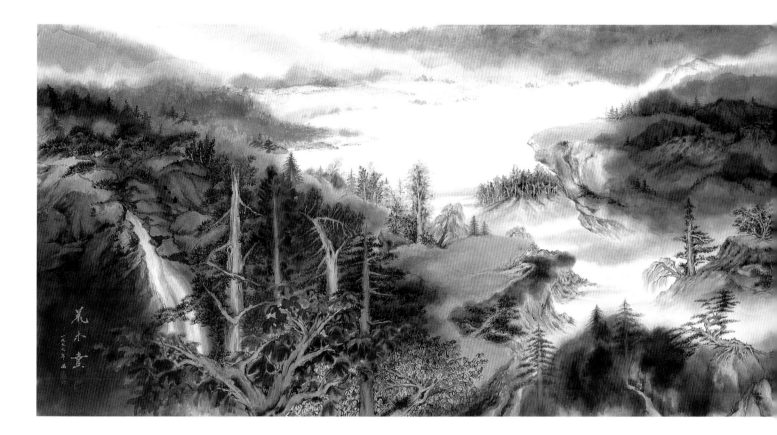

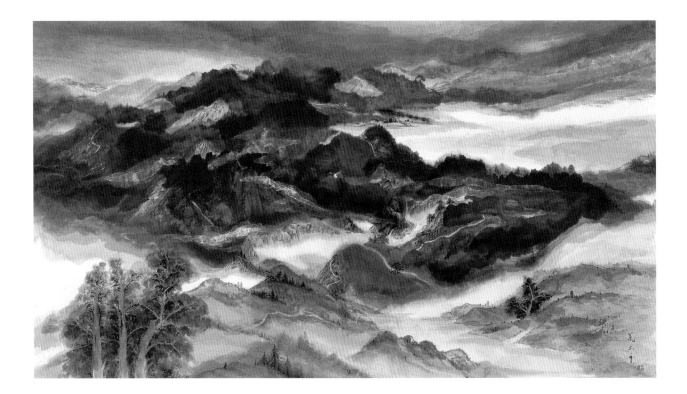

20 | LANDSCAPE
山 水

1996
ink and color on paper, 87.5 x 155 cm

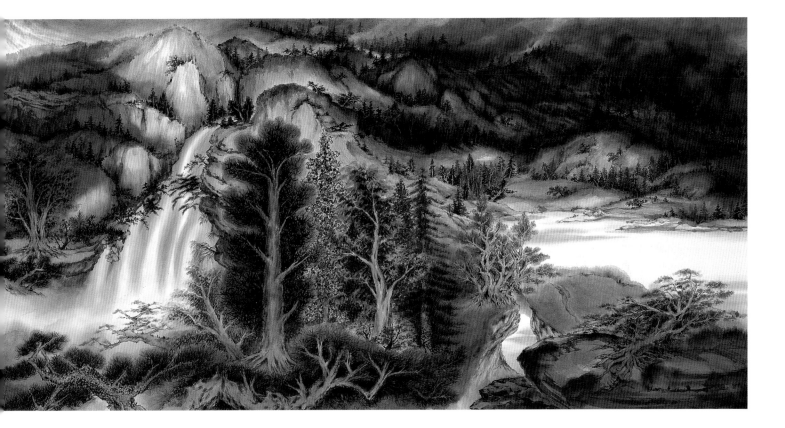

21　LANDSCAPE WITH ANCIENT TREES
古木山水

1997
ink and color on paper, 88 x 352 cm in 2 panels

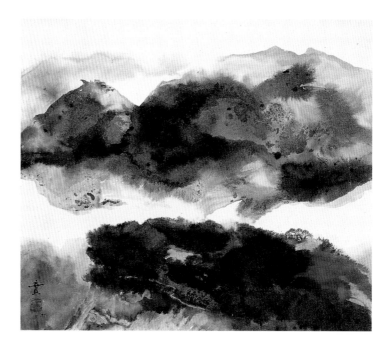

22 | LANDSCAPE
山 水

1997
ink on paper, 39 x 46.5 cm

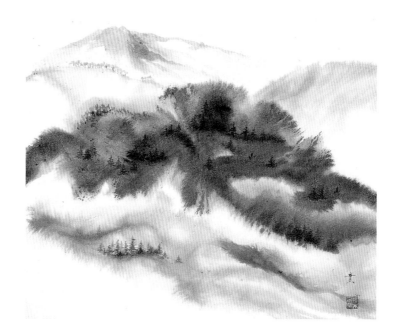

23 | LANDSCAPE
山 水

1997
ink and color on paper, 39 x 46.6 cm

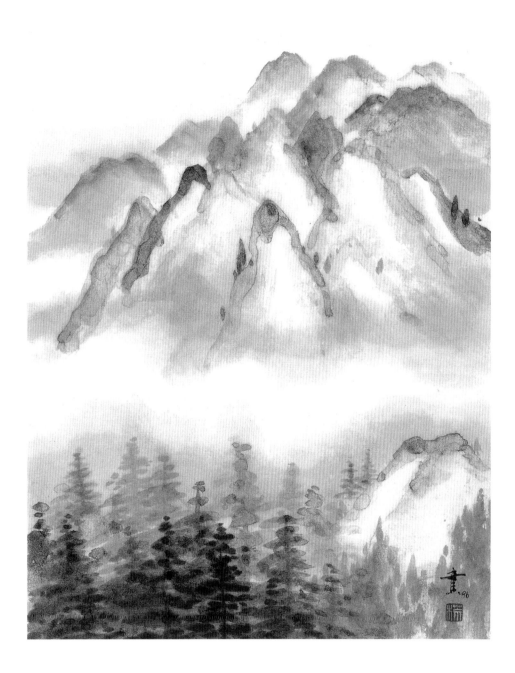

24 SNOWY MOUNTAINS

雪山

1996

ink and color on paper, 34.5 x 26 cm

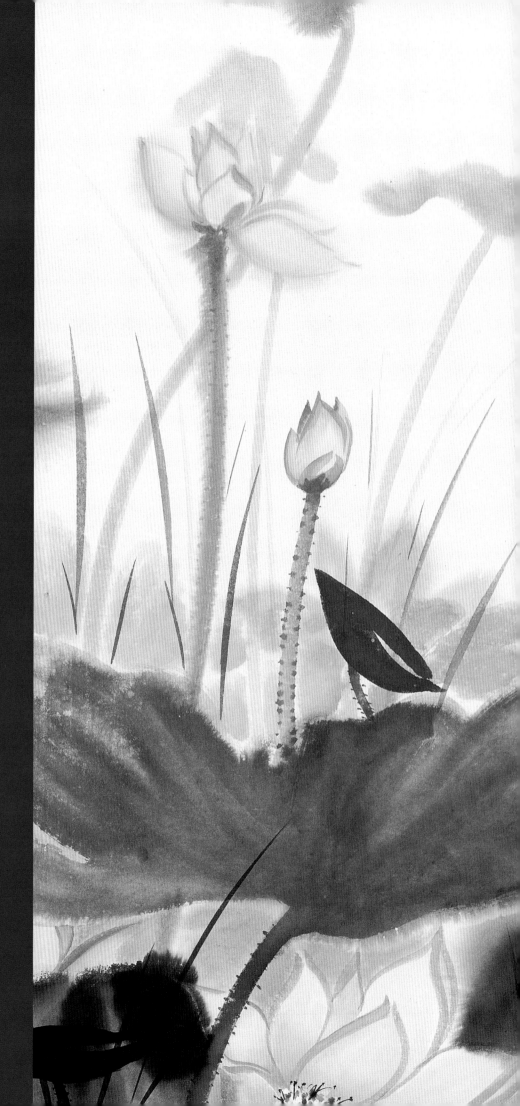

Lotus

荷 花

Graceful and sentimental lotus flowers inspire my imagination. Painting the lotus, called the "gentleman of flowers" in ancient texts, enables me to converse with respected old masters.

多情多姿的荷花，震動了人的
想像力，古記說：繪畫著那一朵
「貴君子」，能與先人們分想
「人間喜怒哀樂」別有趣。

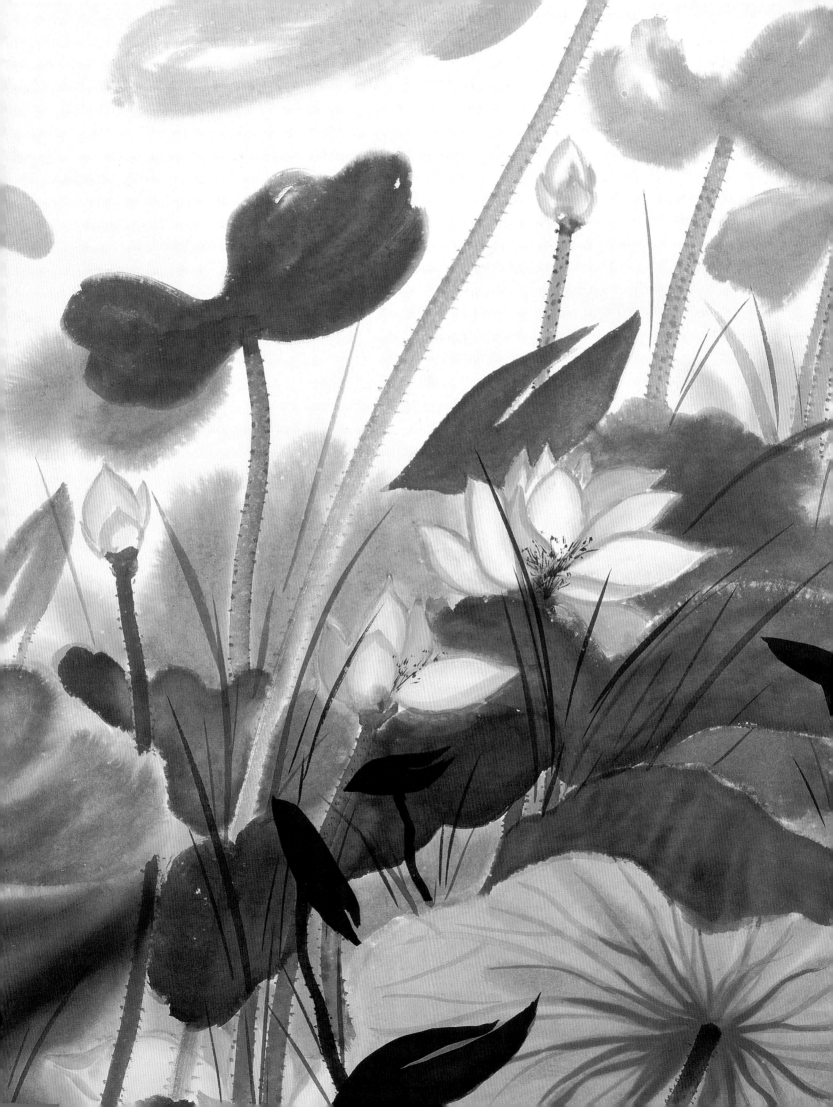

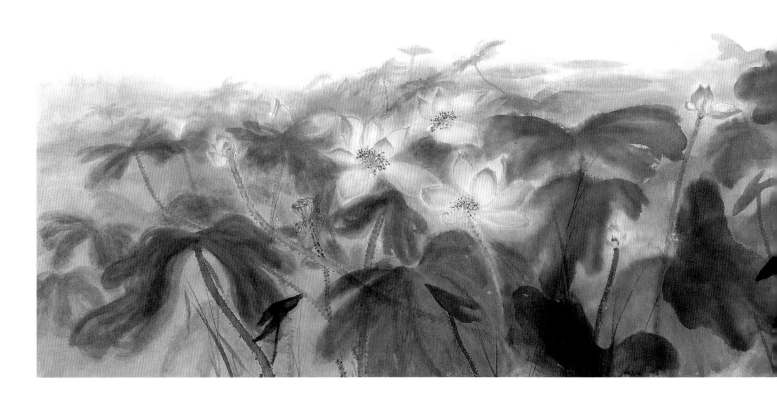

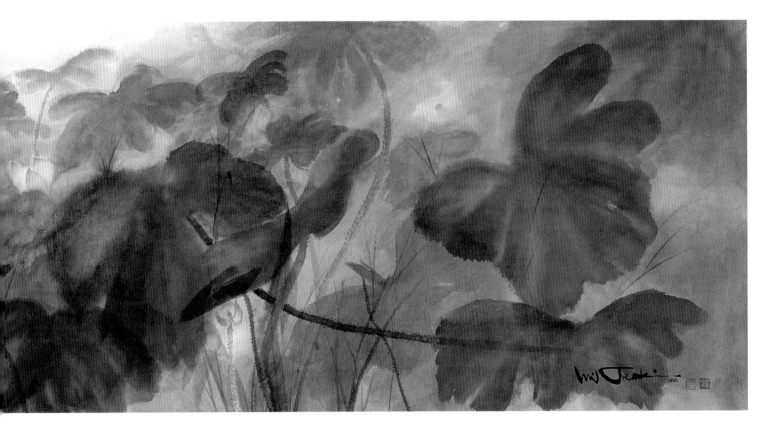

25 | LOTUS POND
荷花池

1986
ink and color on paper, 90 x 360 cm in 2 panels

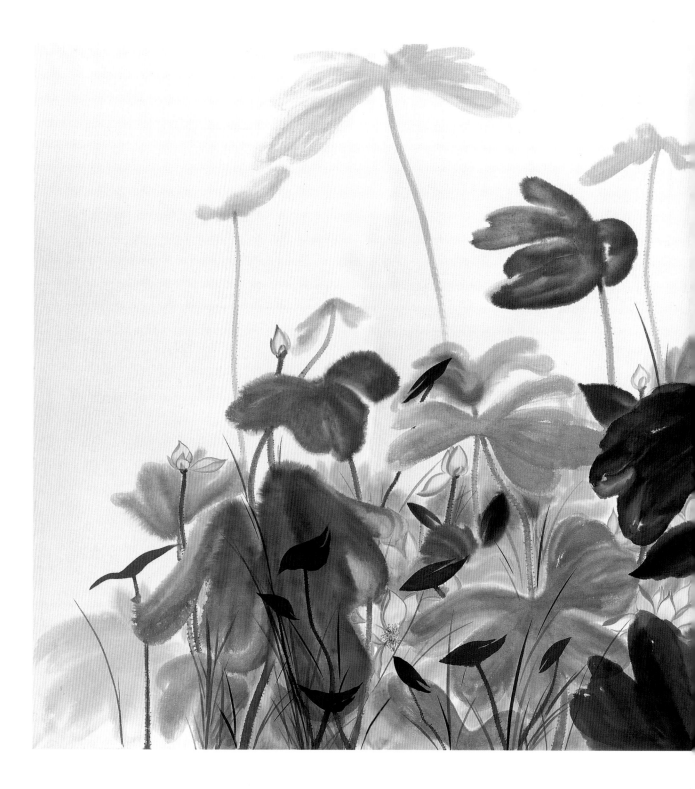

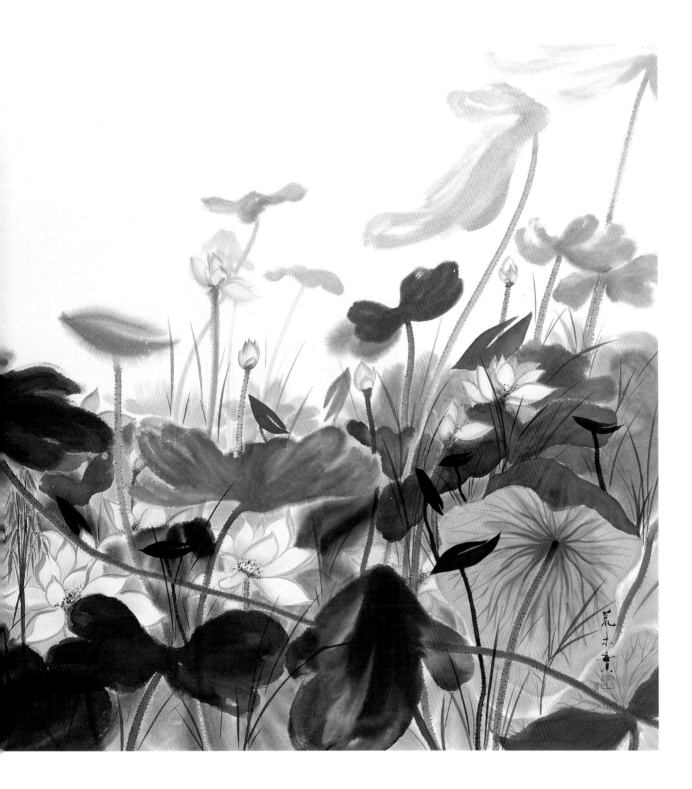

26 | LOTUS POND

荷花池

1992
ink and color on paper, 180 x 360 cm in 4 panels

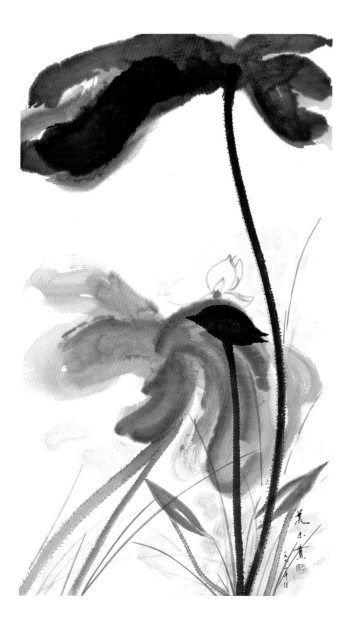

27 | LOTUS
荷花

1993
hanging scroll, ink and color on paper, 94 x 54 cm

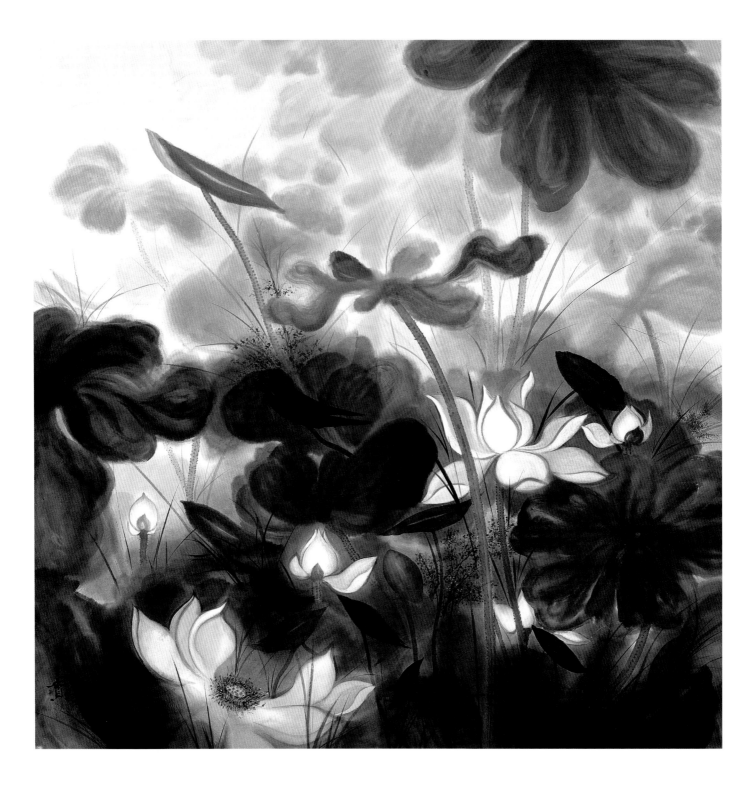

28 | LOTUS POND
荷花

1997
ink on paper, 180 x 180 cm in 2 panels

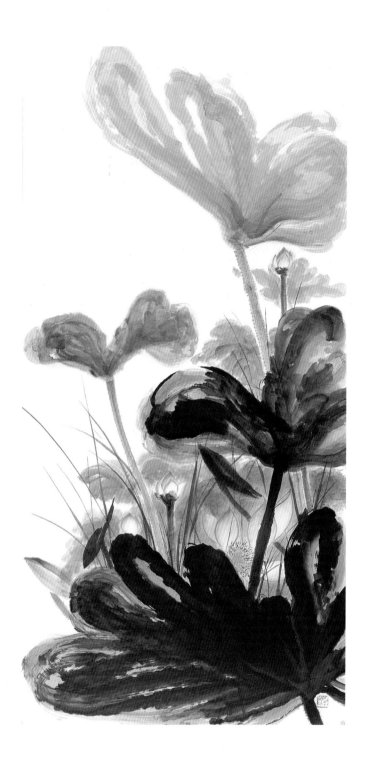

29 | LOTUS
荷花

1996
ink and color on paper, 139 x 69 cm

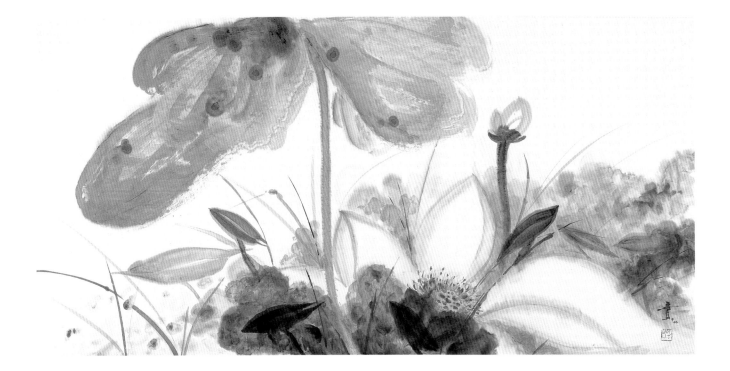

30 | LOTUS
荷花

1996
ink and color on paper, 69 x 139 cm

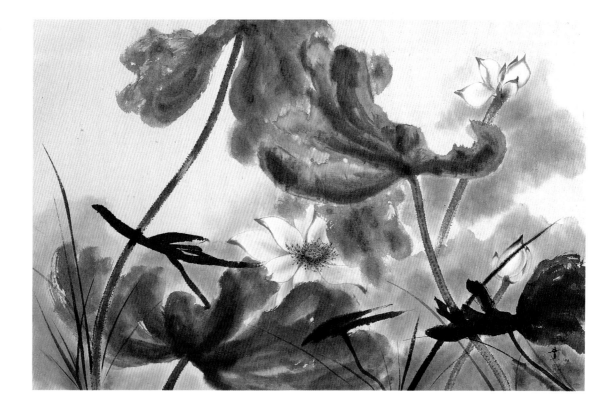

31 | LOTUS
荷花

1996
hanging scroll, ink and color on paper, 63.4 x 96.1 cm

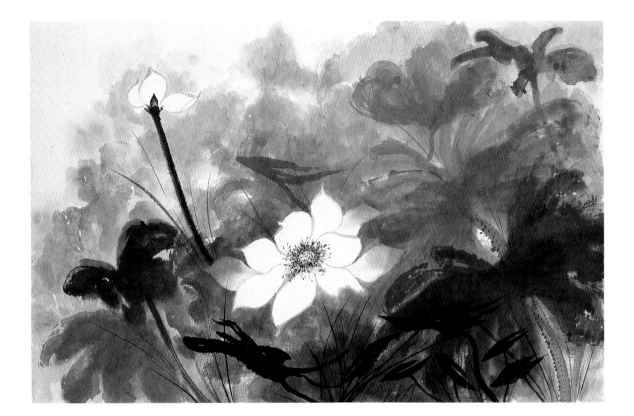

32 | LOTUS IN MOONLIGHT
月下荷花

1996
ink and color on paper, 63.5 x 96.5 cm

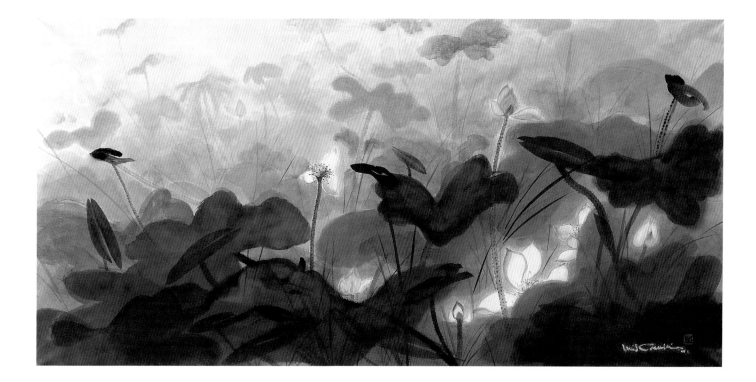

33 | LOTUS POND
荷花池

1991
ink and color on paper, 90 x 180 cm

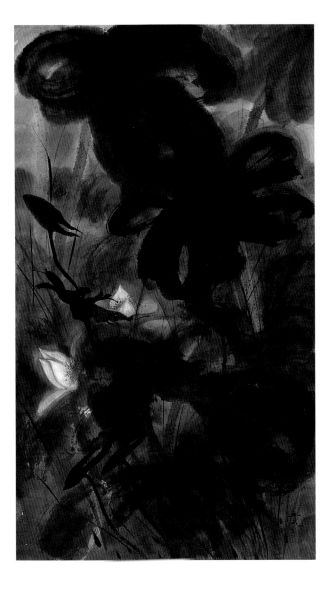

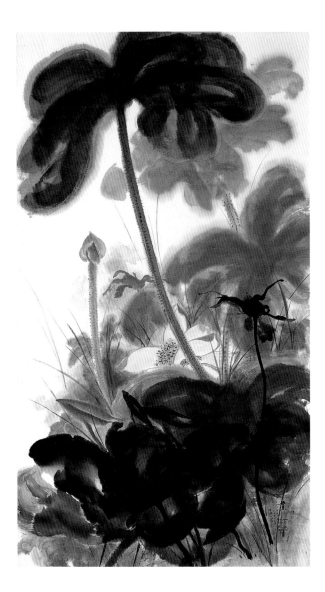

34 | LOTUS
荷花

1997
ink and color on paper, 93.5 x 53.6 cm

35 | LOTUS
荷花

1997
ink and color on paper, 92.9 x 52.7 cm

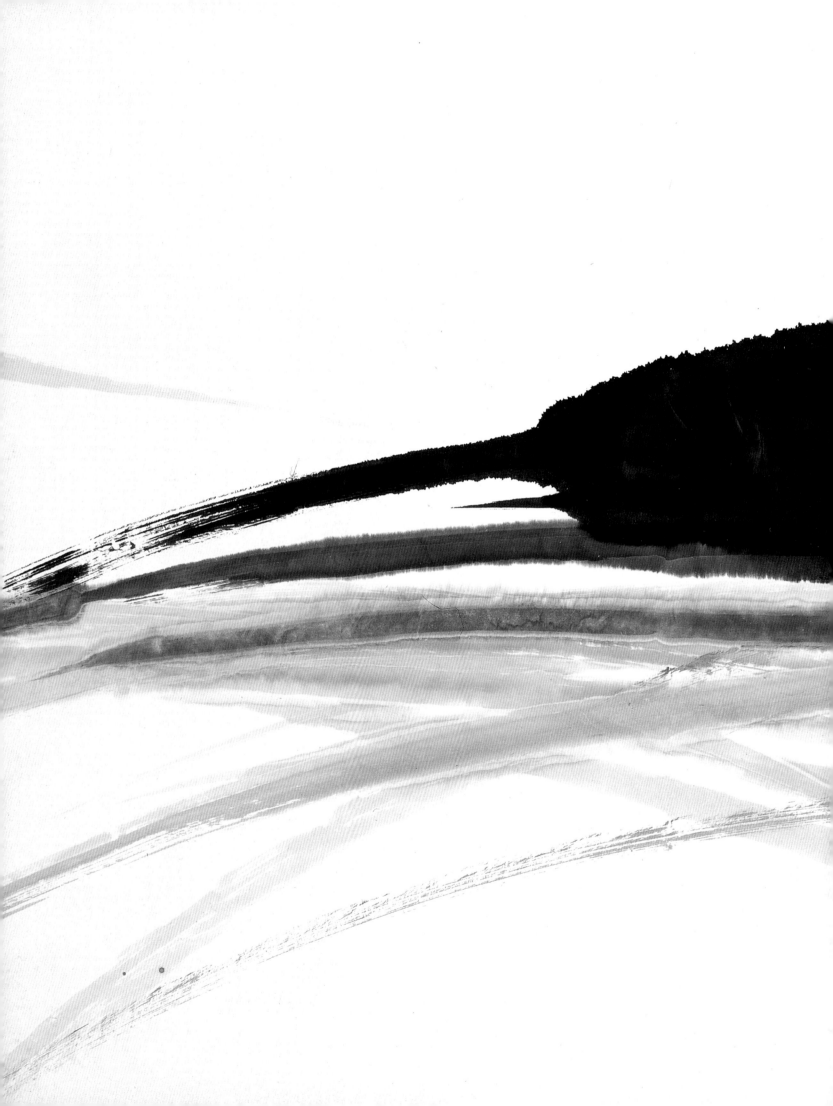

Flowers & Birds

荷 鳥

Even the most commonplace bird or nameless flower possesses a natural beauty and vitality.

小鳥與無數無名花均具有授於
自然之美，且備有強盛的生命力。

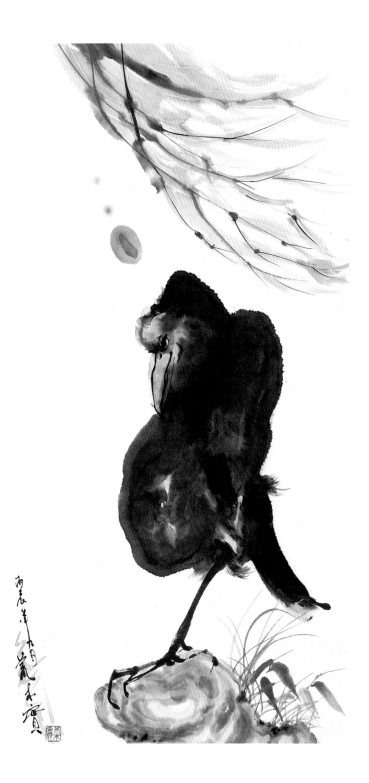

36 | THINKING BIRD

沈思鳥

1976
hanging scroll, ink and color on paper, 69.5 x 34.5 cm

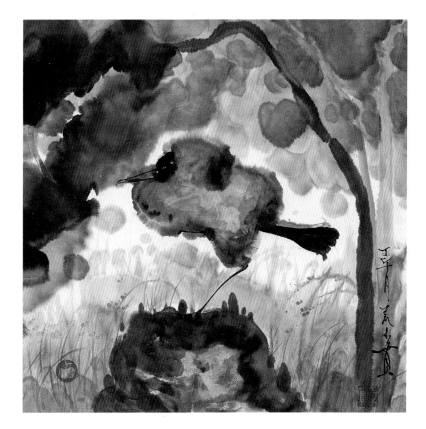

37 ## LONELY BIRD
寂 鳥

1977
ink and color on paper, 34 x 34 cm

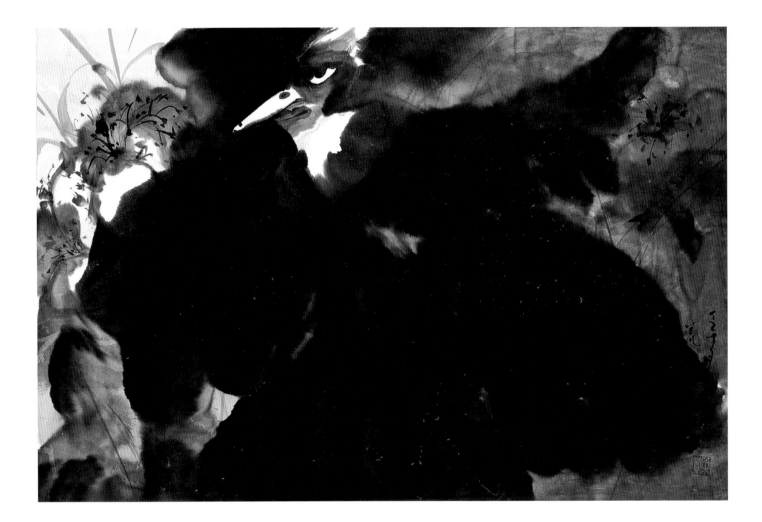

38 | FLOWER AND BIRD
花鳥

1976
ink on paper, 46.2 x 69.2 cm

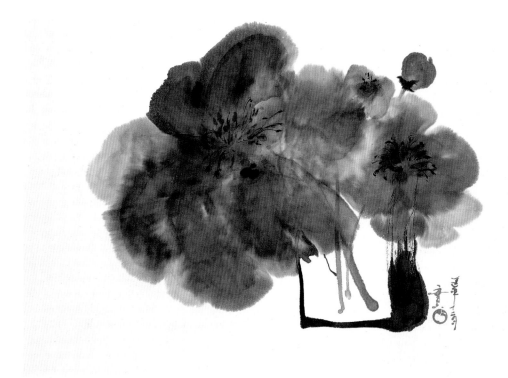

39 | **Two Flowers**
雙朵花

1976
ink on paper, 45.6 x 69 cm

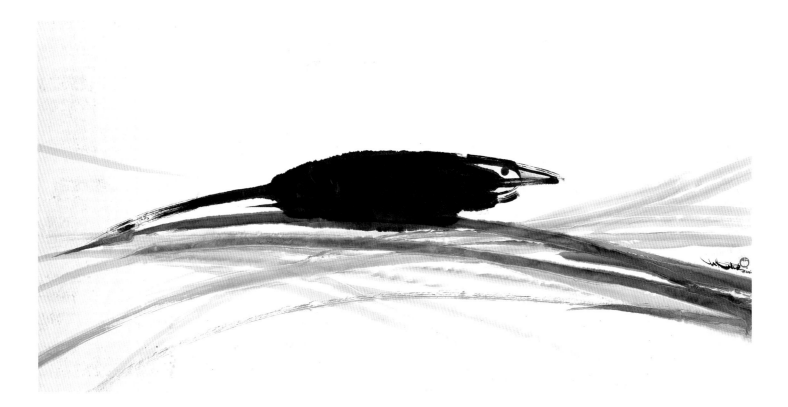

40 | BIRD
鳥

1978
ink and color on paper, 69.7 x 138.6 cm

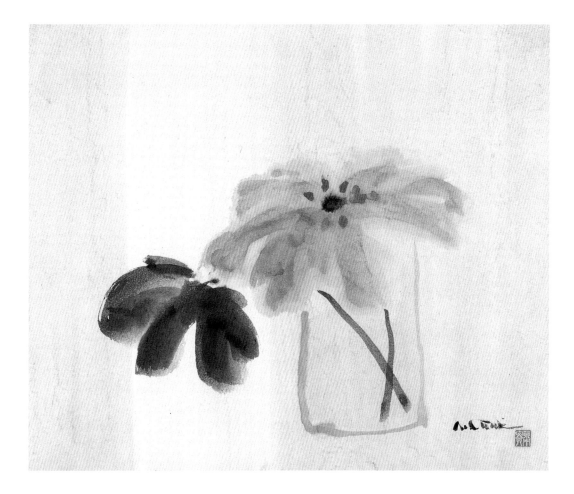

41 | Two Flowers
雙朵花

1975
ink and color on paper, 38 x 45.5 cm

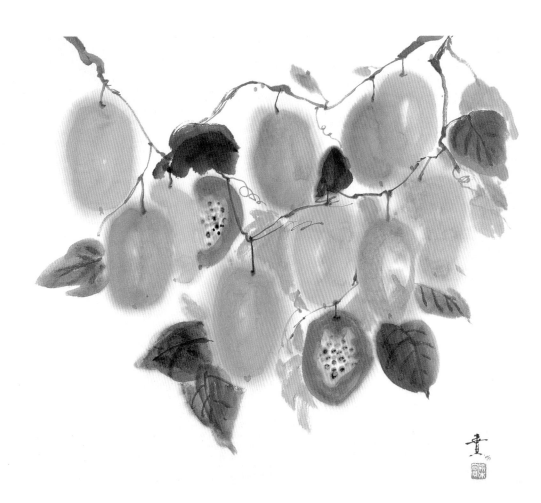

42 | **BAIXIANG FRUIT**
百香果

1996
ink and color on paper, 45.5 x 53.5 cm

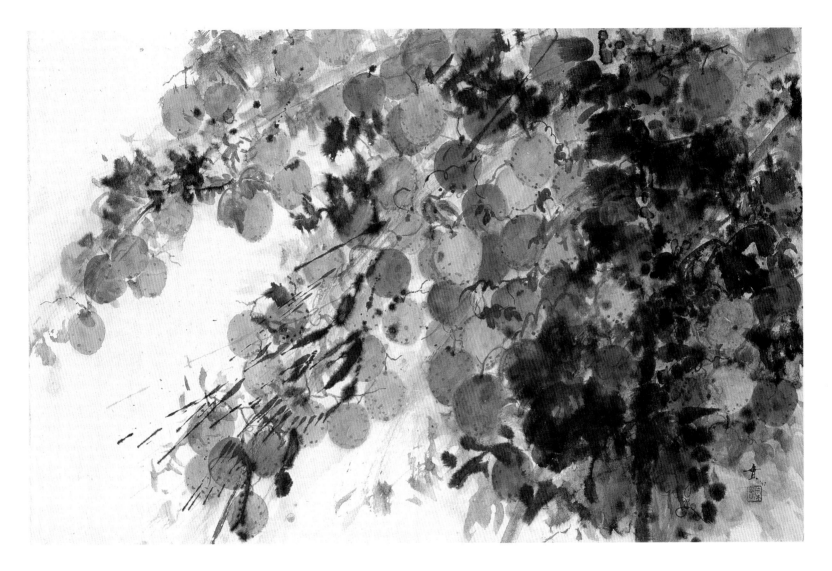

43 | BAIXIANG FRUIT

百香果

1997
ink and color on paper, 63.3 x 96.2 cm

Faces and Figures

人　物

*Finding serenity or shining
splendor in a face marked by harsh
times, I often rethink what life is.*

在不同環境下，從人之素顏，
能找出其「平靜」與「光輝」
且隨時再思考人生。

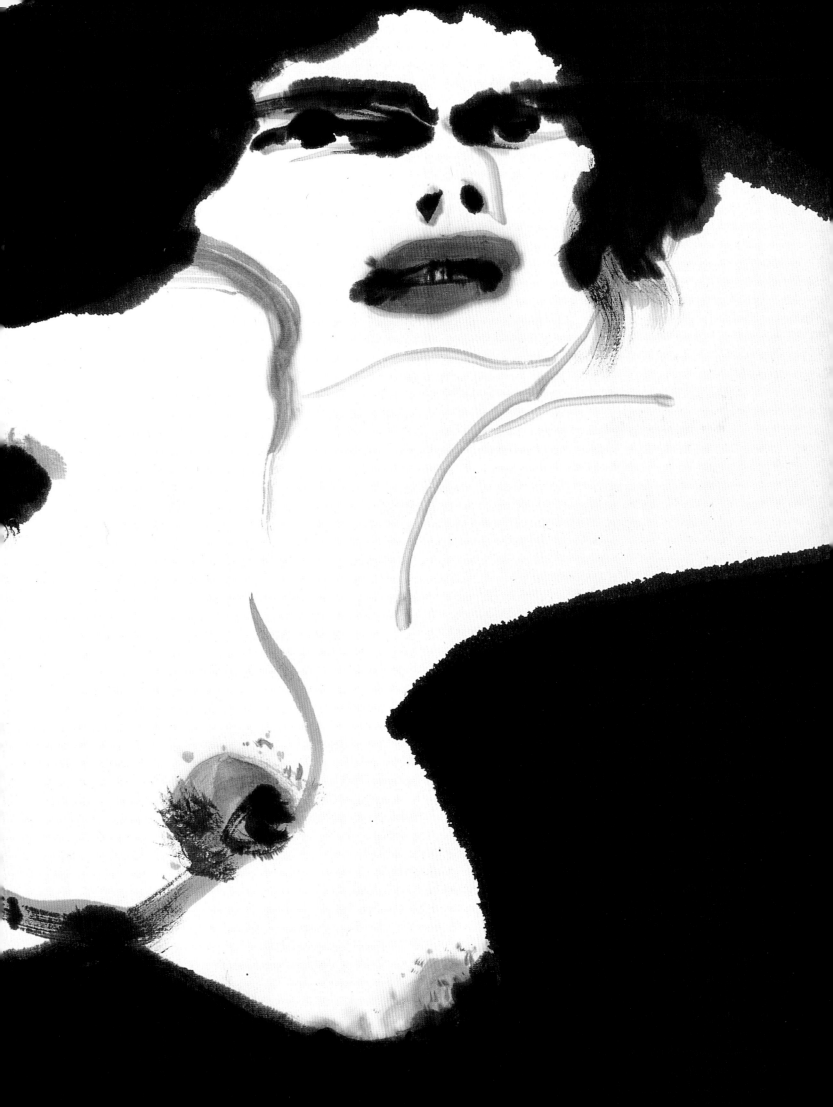

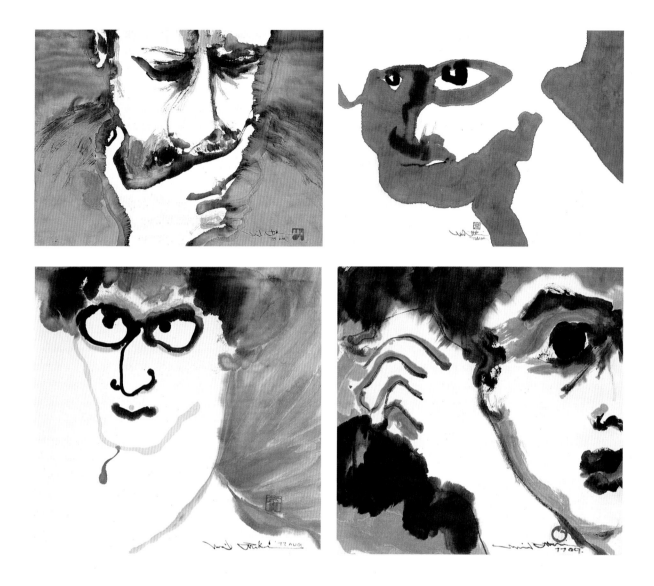

44	THINKING MAN 男 1978 ink and color on paper, 34.2 x 46.5 cm	45	MAN 男 1978 ink on paper, 34.5 x 46 cm
46	MAN 男 1977 ink and color on paper, 34 x 34 cm	47	WOMAN 女 1977 ink and color on paper, 34 x 34 cm

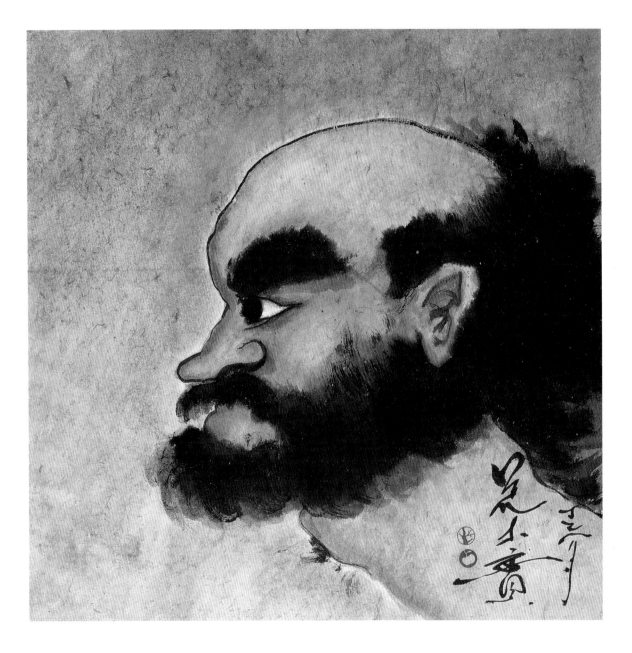

48 | HAITIAN MAN
男

1977
ink and color on paper, 61.5 x 62 cm

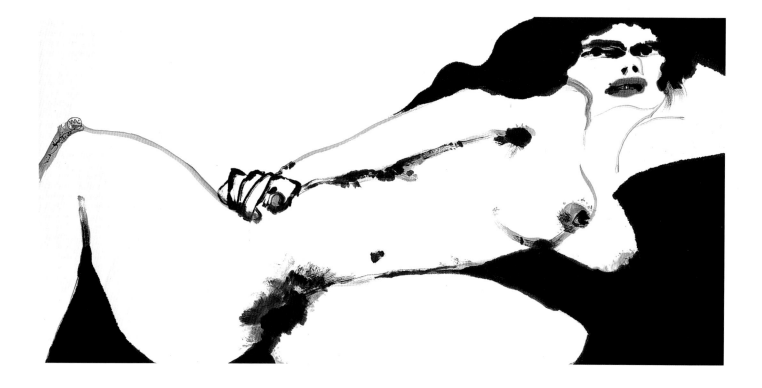

49 RECLINING NUDE

裸 體

1980
ink and color on paper, 69.5 x 140.2 cm

50 | WOMAN

女

1979
ink and color on paper, 45.6 x 67.7 cm

51 | FESTIVAL (MATSURI)

祭

1985
ink and color on paper, 180 x 180 cm in 2 panels

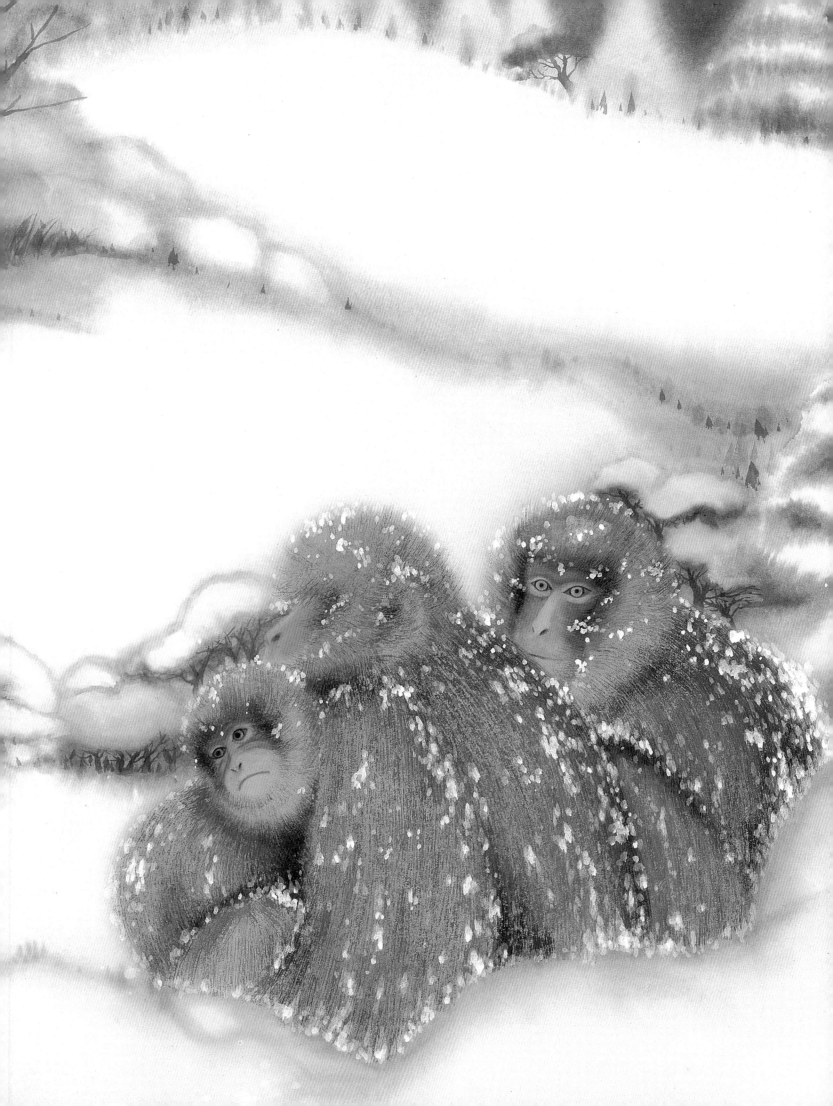

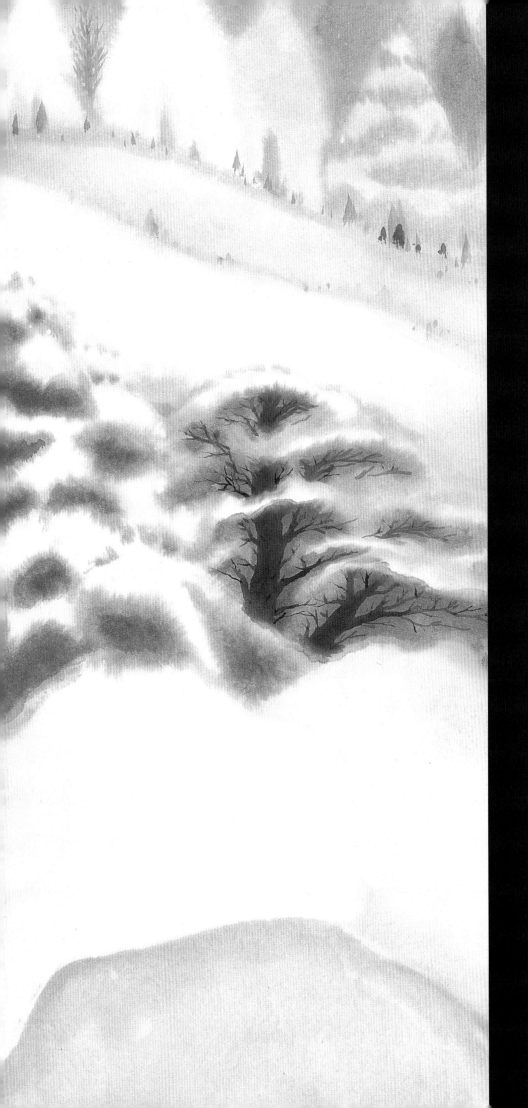

Miscellaneous
Subjects

森羅萬象

*Painting is for me a celebration of
nature, a grateful song to all forms
of creation.*

對我而言，持續的繪畫，是對
自然的贊歌，對宇宙所有創造
物的贊賞。

52 | FIRE ISLAND
火島

1992
ink and color on paper, 46 x 53.5 cm

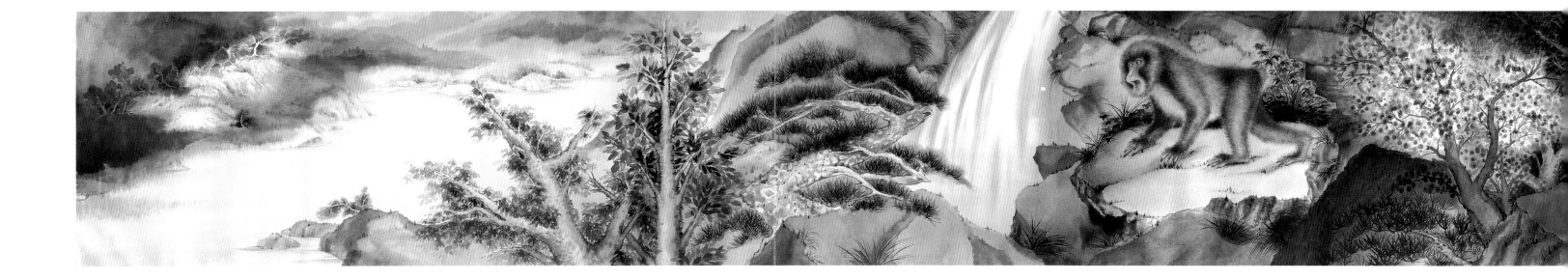

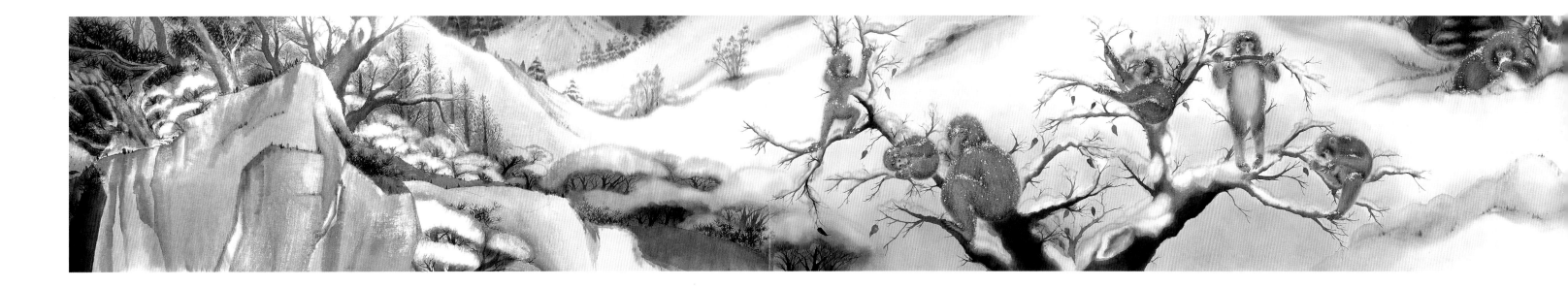

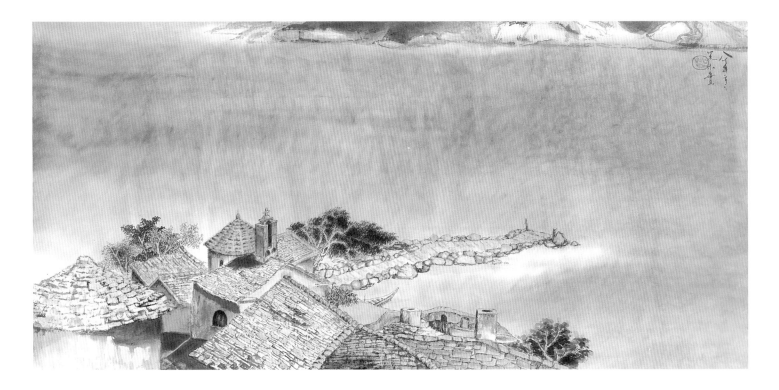

53 | PIER
渡船頭

1980
ink and color on paper, 61.2 x 128 cm

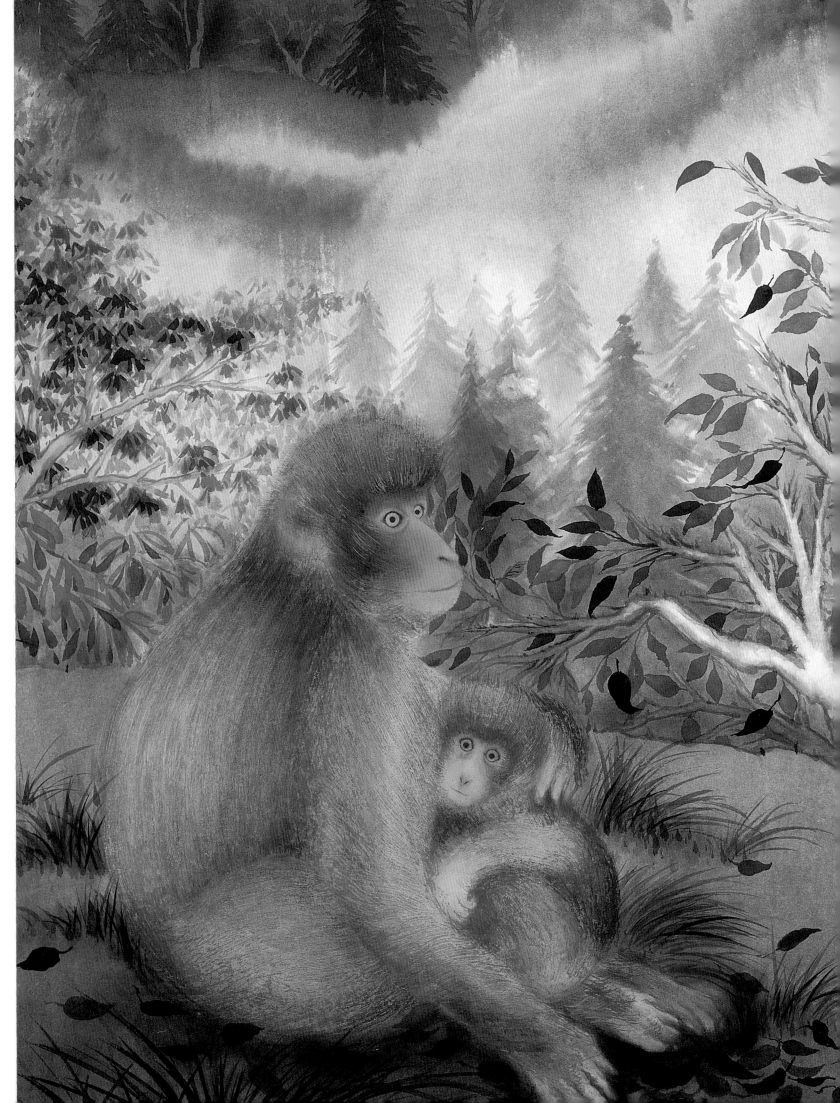

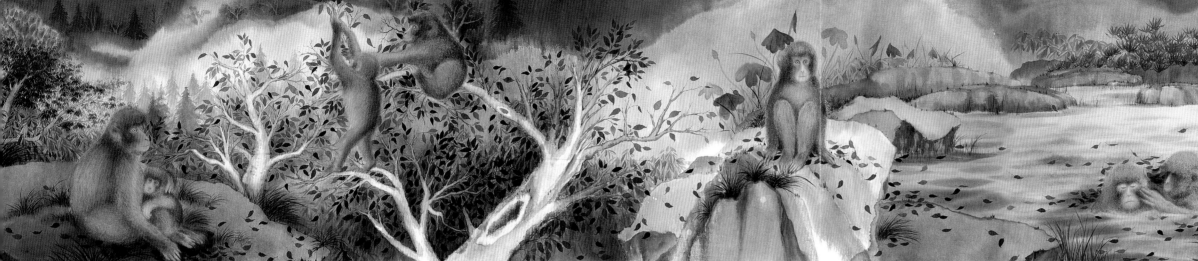

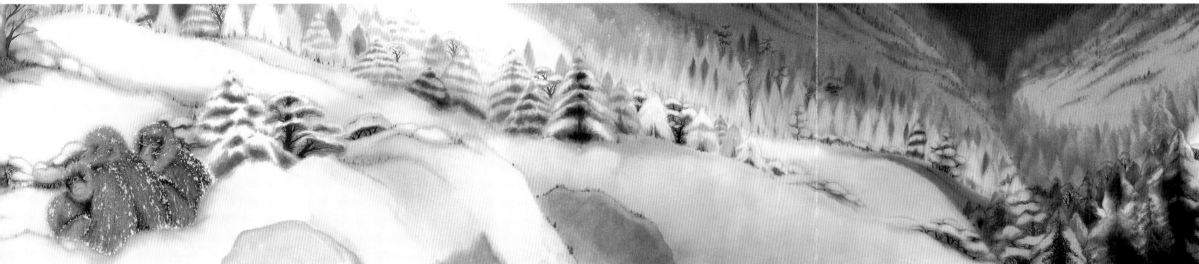

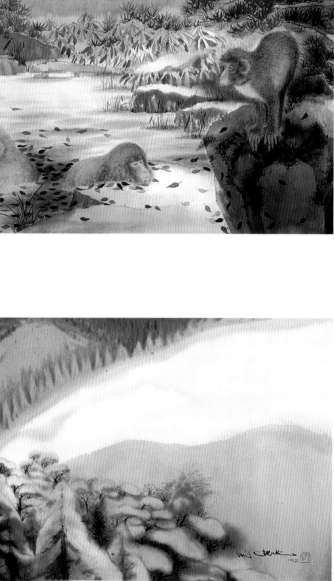

54 SNOW MONKEYS AT PLAY IN AUTUMN AND WINTER
秋冬遊猿

1992
ink and color on paper, 90 x 2160 cm in 12 panels

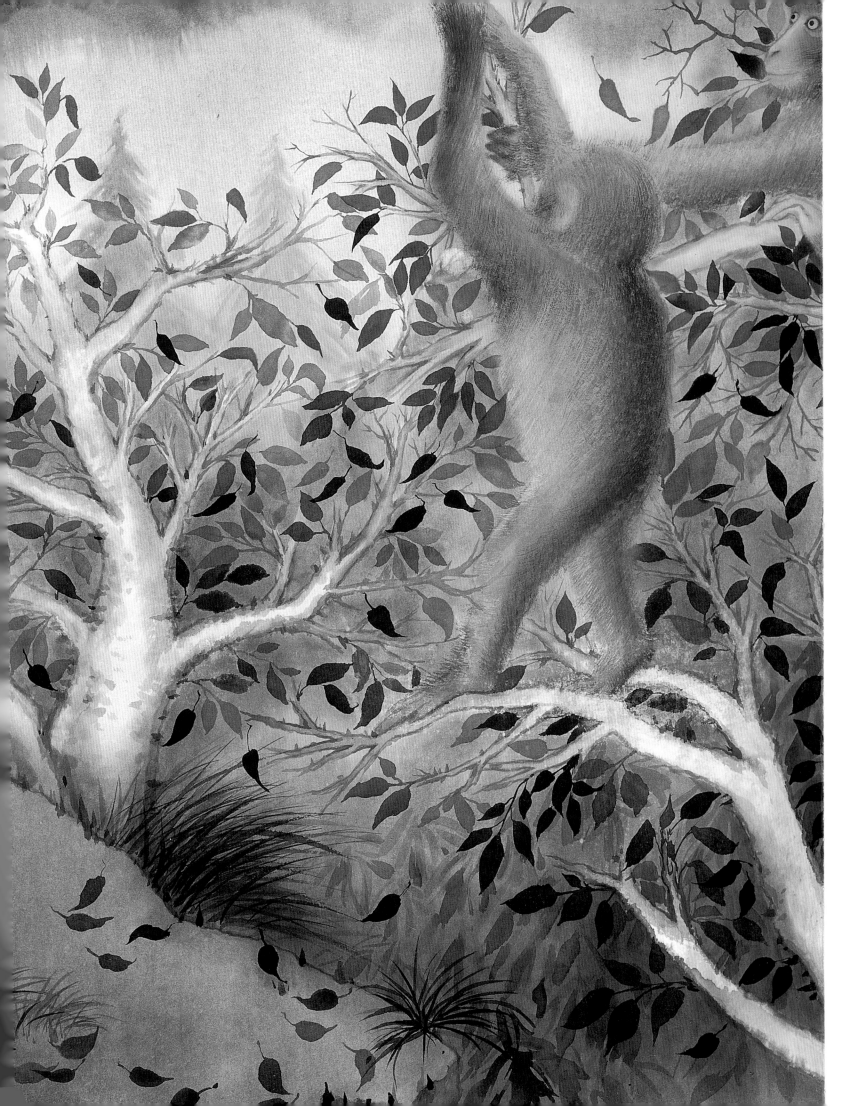

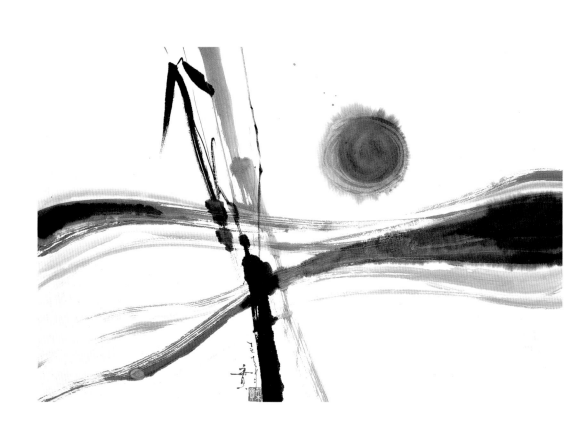

55 ABSTRACTION

抽 象

1976
ink and color on paper, 46.5 x 69.3 cm

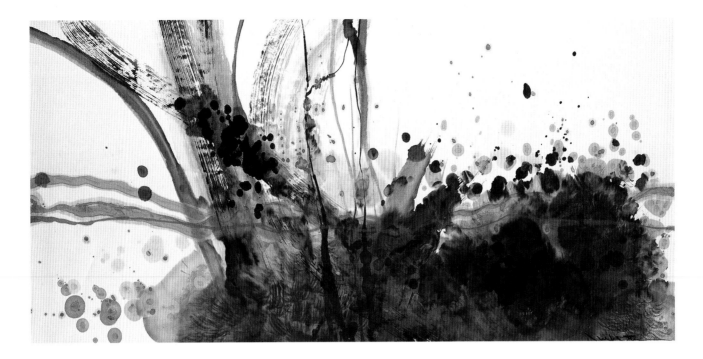

56 | ABSTRACTION
抽象

1978
ink and color on paper, 69.3 x 139.3 cm

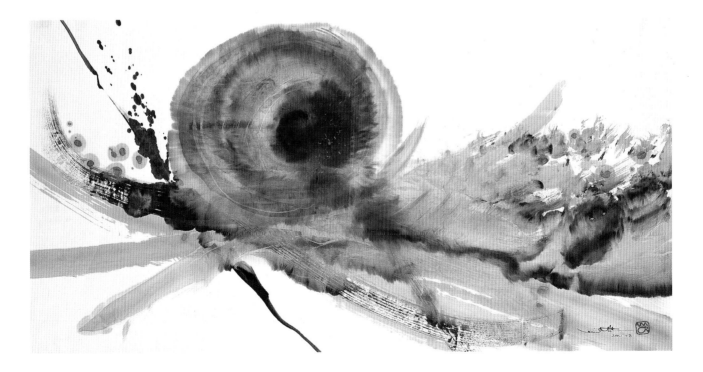

57 | ABSTRACTION
抽象

1978
ink and color on paper, 69.3 x 139.3 cm

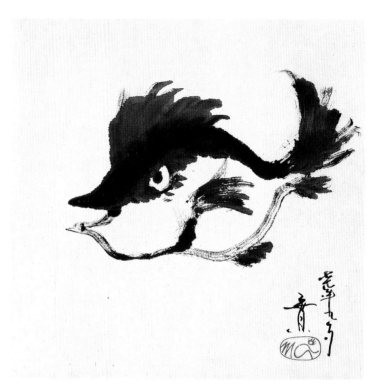

58 | FURIOUS FISH
怒魚

1979
ink on paper, 35 x 34.6 cm

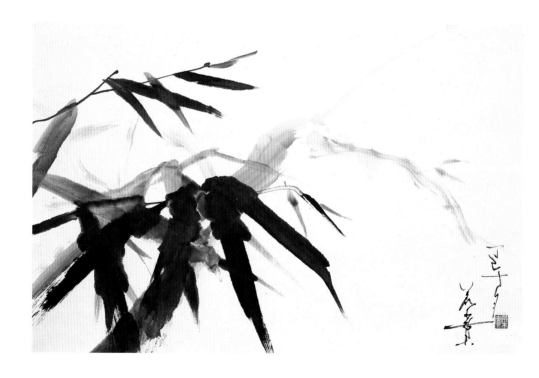

59 | BAMBOO
竹

1977
ink on paper, 46.2 x 49.5 cm

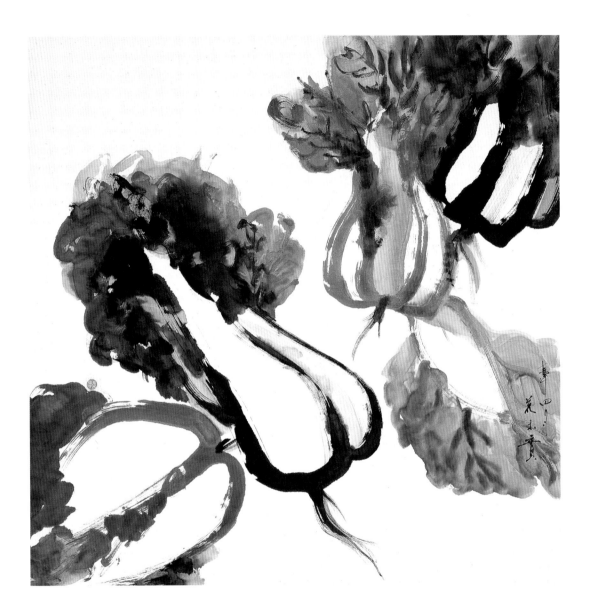

60 | CHINESE CABBAGE
白菜

1976
ink and color on paper, 68 x 68 cm

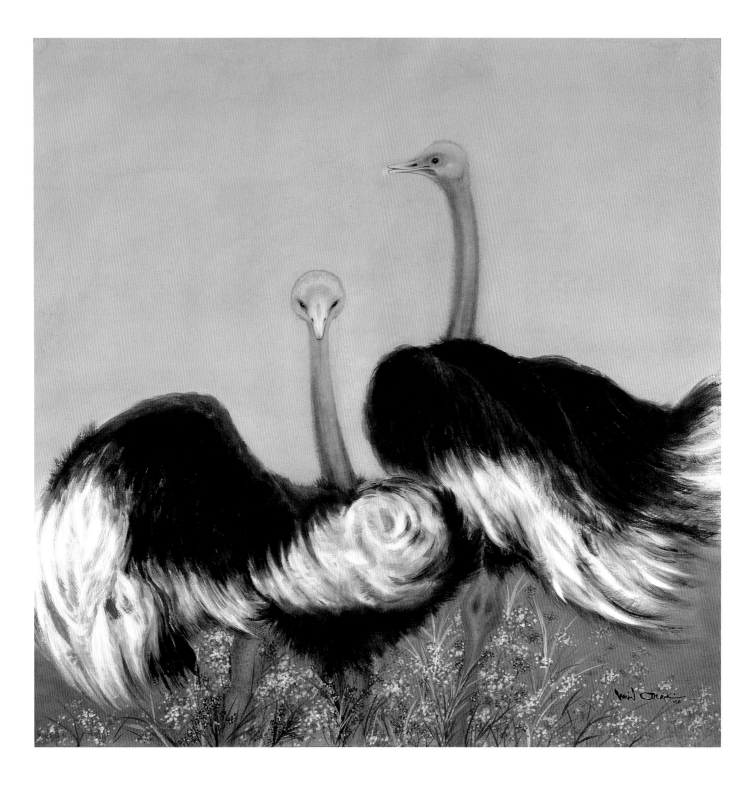

61 | OSTRICHES

鴕 鳥

1992
ink and color on paper, 180 x 180 cm in 2 panels

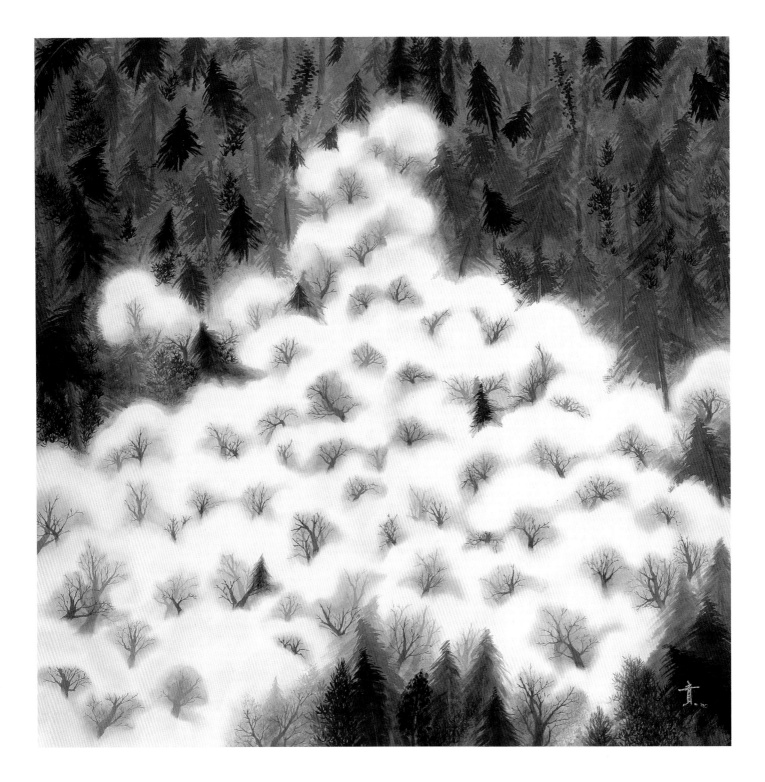

62 | CHERRY TREES LIKE CLOUDS
雲 櫻

1990
ink and color on paper, 180 x 180 cm in 2 panels

PLATES

LANDSCAPES

SELECTED SEALS

Designed by Minol Araki from 1970 onward